The Faces of God

The Faces of God

How Our Images of God Affect Us

by

James D. Hamilton

Beacon Hill Press of Kansas City
Kansas City, Missouri

Permission to quote from the following copyrighted versions of the Bible is acknowledged with sincere appreciation:

The Holy Bible, New International Version (NIV), copyright © 1978 by the New York International Bible Society.

The Living Bible (TLB), © 1971 by Tyndale House Publishers, Wheaton, Ill.

New American Standard Bible (NASB), © The Lockman Foundation, 1960, 1962, 1963, 1968, 1971, 1972, 1973, 1975, 1977.

10 9 8 7 6 5 4 3 2 1

Contents

The Lord is gracious and compassionate,
 slow to anger and rich in love.
The Lord is good to all;
 he has compassion on all he has made.
— Ps. 145:8-9, NIV

I A God with a Face

William Stidger told of a little girl who did not want to go to bed because she was afraid of the dark. Her mother tried to help her overcome her fear by reminding her that God would be with her. The girl replied, "I know God will be with me, but I wish God had a face."[1] Hers is a common wish—to have a God with a face, a God that we can see.

Knowing that God is a spirit does not keep us from wanting Him to have a face so that we can visualize Him better. We somehow feel that visibility and reality are equated. Thus a God we could see would become more real. As one of my students said, "I believe that God loves me, yet this is difficult for me because I can't see Him."

The human mind is constituted in such a manner as to function best with the use of images. Before the days of television, much of family entertainment was provided by radio

programs. The familiar radio characters were not merely names and voices to their listeners. They had faces as real as the faces of individuals we knew personally. How could that be? It was because the mind supplied the listener with a face and a form for each character. These faces were "real" for each listener, though the mental images of the characters might be quite different for any two listeners.

The need for a God with a face is so great that it is not long before He is supplied with one. Although He is a spirit, and therefore invisible, we make Him "visible" by supplying Him with our mental image of Him. **The mental image we have of God determines how we will relate to Him. Thus, we give God a face, and it is how we see His face that determines the nature of our religion.**

How many faces does God have? He has faces equal to the number of persons who contemplate Him. J. B. Phillips, in his book *Your God Is Too Small,* discusses some of the images that persons have of God. Some of these are, "Resident Policeman," "Parental Hangover," "Grand Old Man," "Meek and Mild," and "Absolute Perfection."[2]

While it is true that images can be categorized by general type, there is a distinct sense in which the image of God is highly individualized for each person. These images can range all the way from the view of God as an angry Judge of the universe to a well-known Hollywood actress' assessment of God as being "a great big beautiful Doll." But God always has a face; indeed, He has many faces. This becomes the basis for the title of this book, *The Faces of God.* There is a Hindu saying that God has a million faces. There is a lot of truth in that belief.

In this volume we shall explore the psychological-theological implications arising out of one of the many faces of God, the face of an angry, disapproving, vindictive God. Here are some statements reflecting this kind of God that I have encountered in my work as counselor and teacher:

"I see God the Father as a very large person approximately 2,000 times the size of a human. I see Him as an old man. His hair is white and His face is wrinkled. I see Him as stern and austere, rather than gentle and loving; and yet there is a certain amount of distant kindness in Him."

"I often perceive Him as the Demander, the Grand Expecter who is always pushing me to do more than I'm capable of doing."

"His greatness, holiness, and power frighten me."

"I am tempted to believe in His vindictiveness . . ."

"I am *so* afraid of God."

"I feel I committed the unpardonable sin by being angry with Him."

These responses reflect inner agony and conflict. They point out graphically the trauma with which countless persons live with regard to the nature and character of God. Based on the distorted images that these persons have, this is what God is like: He is aloof, remote, judgmental, temperamental, vindictive, demanding, unbending, capricious, and threatening. Other common fallacies regarding the nature and character of God present Him as One who initiates wars, causes sicknesses, and takes the lives of loved ones. The old burial service included the phrase, "Inasmuch as it pleased God to take out of the world the soul of the departed . . ." What a negative, dismal view of God. Such a God is not even a Christian! It is no wonder that many persons have difficulty relating to Him.

One would think that these appraisals of God would be those of unbelievers. The amazing, but tragic, fact is that every one of them was a professing Christian. Some were either in ministry or were studying for ministry. This has led me to the belief that there are countless professing Christians who struggle daily with life's most fundamental question: What is God like?

This book is not an argument for the existence of God. For centuries theologians have been engaged in this study. The well-known "arguments for God" have posited that He is known ontologically (the way that truth is known to be true and reality is known to be real); He is known cosmologically (the way that we know that there is a source and ground of the universe); He is known teleologically (the way that we know that there is meaning in life); and He is known morally (because of man's moral awareness).[3]

Instead of an argument for the existence of God, this book is an argument for the nonexistence of God. That is, it is an argument that He is *nonexistent* in the way that He is perceived by many as being. This book begins as does the Book of Genesis: "In the beginning God . . ." (1:1). The quest is not for the "ifness" of God but for the "whatness" of God.

On returning from a world tour, Dr. R. T. Williams was asked for his most impressive observation. He replied, "The fact that the whole life of a people can be so greatly influenced by their conception of God."[4] But this is so for an individual as well as for a people. One's view of God is *the* foundational issue. If that view is valid, it makes for both health and happiness. If the view of God is distorted, it results in feelings of alienation from Him, feelings of alienation from oneself, and often feelings of alienation from others.

It should be pointed out that it is possible that a person can accommodate the "God is love" concept in a general sense, and even in a specific sense when applied to *another* individual, but it loses its meaning when he attempts to relate it to himself. Thus one can even preach a sermon on the love of God and convince others that that love can be both personal and knowable, while, at the same time, experience alienation from God *at the level of one's inner feelings.*

One minister with whom I counseled said, "I could preach about as good a biblical sermon on the love of God as the next minister, but at the level of my own feelings I was not

aware of God's love for me." The turning point in this therapy came when he was able to verbalize this deeply repressed feeling: "I feel that my wife loves me more than God does." To some this may not seem to be progress at all. Indeed, to some it may seem to be a step backward. In fact, however, it was a grand moment of truth when he could become honest enough with both himself and with God to disclose his inner feelings. Through a combination of coming to a clearer concept of God and gaining a more wholesome concept of himself, he began to make giant, swift strides out of the morass of his spiritual-psychological trauma. Much later he wrote to me relating that he was continuing to experience inner release and freedom and that he was enjoying ministry as never before.

The concept "God is love" has its greatest significance not in the universal but in the personal, subjective sense.

For many years I have asked my students and my counselees to engage in a short, impromptu exercise that aims at describing their personal views of God; or, to use Thomas Harris's term, their "felt concept" of God. They are asked to write a brief description of God as He is personally perceived, not drawing on their knowledge of academic theology or on what the Scriptures teach regarding the nature and character of God. The results are both amazing and disturbing, as we shall see later.

The reason for understanding one's personal perception of God is that this is the "real" God for any given person. Inasmuch as operational reality to any person is how he perceives it, the view that one possesses of God, deep within his psyche, is the "true" God, the God to whom he relates and the God he attempts to serve.

Psychologists are keenly aware that there can be a great gap between what one knows and how one feels. This cleavage between knowing and feeling, the cognitive and the affective, is often experienced in human relationships. This cleavage

can also be experienced in regard to one's relationship with God. Thus, while one's knowledge of God may be valid, the way that one feels about God may be distorted.

Since the time of the ancient Hebrews there has been a belief in monotheism. The biblical record is, "Hear, O Israel: The Lord our God is one Lord" (Deut. 6:4). But the "one God" is many Gods—as many as the number of persons contemplating Him.

Here is a description of God that was given to me by a theological student:

> I see God as a stiff unbending policeman who is accepting me conditionally. When [I am] working with others it is not difficult to see Him as compassionate, merciful, and kind—responsive to their needs. But many times, in relation to *me,* I see Him as One who needs to be begged and pleaded with, even for my necessities. This seems foolish to me because my mind and my heart are not consistent with each other.

Let us examine the implications of that description. Here is a minister-in-training who is living with a dualistic God. On the one hand God is stern, austere, and unapproachable. On the other hand, He is compassionate, merciful, and kind. These two sets of perceptions are contradictory. Actually, he is speaking of two Gods, the God other people have and the God he has. When ministering to others he presents the God of his *knowing;* that is, he presents to them the God of his biblical-theological knowledge. The other God is the God of his *feelings;* that is, of his personal perception of God.

It is the latter God, the God of personal perception, who is the *real* God for this young man. Thus, in the attempt to relate to this God, he is uncomfortable in His presence. He feels unsure of where he stands with God, and he is fearful of Him. The God who to others is compassionate, merciful, and kind is a very different God to him. His God must be "begged and pleaded with" for even a supply of daily, legitimate needs.

The closing sentence of his statement about God is very significant. He said, ". . . my mind and my heart are not consistent with each other." Therein lies the trauma for many Christians: the cleavage between mind and heart, the difference between the objective God and the subjective God. It is the gap between what one knows about God and how one feels about God.

Another person said, "I feel that God is all-sufficient for someone else, but I have trouble trusting Him completely for myself and my own needs."

Another theological student had a striking way of describing this problem. He said, "I sometimes feel that God has a split personality. The concept that 'God is love' contrasts greatly with my view of God who is cruel in His judgment upon humanity. This dualism bothers me greatly."

A schizophrenic God? On the surface it sounds both ridiculous and irreverent. Remember, however, I am not reporting the views of unbelievers; rather they are the views of persons who were trying to live out their Christian faith. If I were convinced that these were but a few isolated cases of persons who were struggling to come to a clearer understanding of God, I could not justify the time and effort in writing a book on this subject. Unfortunately, these perceptions reflect a wide segment of people who are trying to live out the Christian faith but who are having great difficulty in doing so.

Let us return to the cleavage between the objective God and the subjective God, the cleavage between knowing and feeling. A minister I know said, "I believe that it [God's love] is there to be found, but I feel hypocritical over the fact that it is not an ever-present aspect in my own life." Imagine the inner trauma with which he lives daily, of feeling alienated from the very God that he preaches to others is a "very present help in trouble" (Ps. 46:1).

A minister wrote this to me:

My concept of God the Father necessarily comes from my feelings about Him. I interpret God through my feelings. At present, God is far away, inaccessible, hurt and unforgiving. I can see the theoretical fallacy, but I am not able to do anything about it. I'm caught in this view of God, and it affects my relationship with Him, with others, and my self-concept.

The dualism between the objective God and the subjective God is especially painful for ministers because they experience feelings of being a counterfeit when they do not personally, subjectively feel what they tell others that they can experience.

A theological student said, "I am told that God loves me, but I am having a hard time relating that to *me.*" The feeling that God is a God for others is not an uncommon one. Unless and until the objective God is accepted subjectively, at the level of one's feelings, there will be a gap in the life of the believer.

A young woman, a minister's daughter and the wife of a minister said, "I don't feel God loves me. He will love me only if I do better." This view of God has forced many persons into a theological system that is based on works, not grace. The "God will love me if" theology is common and it contains a built-in hazard that its adherents cannot easily overcome. That hazard is this: At what point does one get to the place where he feels he has earned God's love? Obviously, that point is never reached. It is like the fable of the donkey and the carrot. The carrot is always out of reach. The reward is visible and desirable and, seemingly, it is reachable. All it takes, it seems, is one more effort. But after each of these efforts the reward is still the same distance away.

A theology of works promises so much but provides so little to its adherents. It provides only the knowledge that one has *really tried,* but that is little satisfaction to one who is

longing for the inner feeling that he is truly loved, truly accepted, and truly a child of God.

Instead of being able to put one's weight down on the fact that "God is love," one carries within himself a deep feeling of alienation from the very One he is seeking to serve. A young woman said, "I feel that God thinks I'm naughty. My mind knows better, but that is how I feel. I have known for years that what I know about God is not the same as what I feel about God." This dichotomy within her caused her to feel alienated from God.

The most striking case that I have seen of the cleavage between the objective God and the subjective God was a young pastor who had graduated with honors from seminary. He said, "My greatest need for healing in my life is how I feel about God. I need to know that God cares for me and loves me and will not 'whop' me. I need to feel that He cares for *me,* that He does not hold things against me."

As with many persons with a negative image of God, he was suffering from low self-esteem. The feelings of alienation from God and alienation from self produced an anxiety-neurosis in him that was producing serious physical symptoms. His brilliant mind was capable of giving him the insight that his greatest need was the healing of his subjective view of God. His ministry was to the poor of the inner city. He had a deep desire to bring God's message of love to those whom society had hurt and rejected. Sadly, he was poorer than his parishioners because he could not bring himself to feel that God truly loved him.

A lovely young woman, the wife of a minister, confessed this to me: "I feel that God does not love me. I feel He may want to get me out of my husband's life." Her feelings of unworthiness were translated into a belief that God felt toward her as she felt toward herself. This caused her to feel that she was a millstone around her minister-husband's neck. That is why she assumed that God wanted to get her out of her hus-

band's life. Her mind knew that God would not end a marriage in order for His work to be accomplished, but that is how she felt.

She described her view of God as follows: "God is standing over me as a threat; He is not kind, but scolding. He is hard to please and is never satisfied with me. It is hard to think of Him as being close. He seems so far away. Being a Christian [with this image of God] *is such a struggle.*" As she said, "such a struggle" it was as if her whole being was heaving a sigh.

Therein lies one of the tragedies of living with a distorted image of God—it truly is a struggle to be a Christian. God is always beyond reach, He is never satisfied, and He always demands more than one can produce. The intrapsychic conflict becomes almost unbearable. How can one please a God who seems to be unpleasable? How can one love a God who seems to reject him? Tragically, many are held captive in this trap.

It is likely that some who now read these pages are caught in this trap. If so, there is good news for you. The good news is that you can be released from this captivity and that you can come to see God in a new light. It is my intent to help you find a new and better way of relating to God.

*

Thou hast made us for Thyself
And our hearts are restless
until they rest in Thee.
—St. Augustine of Hippo

*

"To whom will you compare me?
Or who is my equal?" says the Holy One.

—Isa. 40:25, NIV

2 How Did God Get to Be like That?

A distorted view of God is acquired, it is not inborn; it is learned, not natural. Certainly God would not have created man with a distorted view of himself that He knew would take years to overcome. Rather, He created man with both the capacity and the desire to be rightly related to Him.

The title of this chapter, "How Did God Get to Be like That?" refers not to what God is but how many have come to feel about Him. A common image of God is that He is an old tyrant who is cantankerous, hard to know, and hard to please. He wears a white robe, His hair is long and white, falling over His shoulders. He is seated in an ivory throne-chair, which He has judiciously placed at the edge of the balcony of heaven so that He can have a full view of all that is going on in the earth below. He looks angry, has a scowl on His face, and in His

mighty hand He holds a club that He can use to bash those who displease Him.

Is this image overdrawn? Indeed not. This is the view many persons have of God. Is it any wonder that such persons feel uncomfortable in His presence? Is it any wonder that many find it difficult to relate to Him? Is it any wonder that many find it difficult to pray? How could one be comfortable in the presence of a God like that? One would feel that God should be approached on tiptoe, being careful not to incur His wrath.

God got to be like that, primarily, through the power of early impressions created by the profound influences of authority figures who, themselves, had unclear, if not distorted, views of God. While a distorted view of God has its genesis in youth, it is by no means confined to one's early years. It is not only the young, the unlearned, and the theologically illiterate who can hold this view; it can also be the view of the mature, the educated, and the theologically informed.

The "stamping" process that begins in youth can be unbelievably powerful, persisting in spite of the passing of years and the acquisition of knowledge, including theological knowledge. Many have said to me, "I know that God is not the way I view Him, but that is the way I feel about Him, anyway."

Theological language has a part to play in this matter, particularly the term *Father* in reference to God. A. Donald Bell, in his book *The Family in Dialogue,* records the account of a primary Sunday School teacher who referred to God as a father. She overheard one girl who whispered, "If He's like my daddy, I'm not so sure I'd like to live in heaven with Him at all."[1] It is said that Martin Luther could hardly bring himself to pray the Lord's Prayer and to say, "Our Father" because of the sternness, the strictness, and even the cruelty of his own father.

Other illustrations of theological language in reference to

God are terms such as *almighty, all-knowing, all-seeing,* and *ever-present.* To one who is already struggling with a distorted view of God, these terms can be traumatic in their implications. So frightening are these terms that one may repress them so that they become, as Dr. John Larsen says, "an unconscious, unspoken theology."[2] A lot of our theology, however, is conscious and spoken. This is the theology with which this book deals.

Roy L. Smith, in his book *Making a Go of Life,* tells of a dour old Scotsman who was forced to make an unwanted choice. He exclaimed: "I don't like it! It's not decent! It's not honest! It's not fair! It's not Christian! But it's the will of God and I will do it."[3] This illustrates the incongruity with which one can live if he has an unclear image of God.

The assertion was made that such a view of God is generated from early impressions due to the influences of authority figures. These influences are both formal and informal. Let us examine them.

Formal Influences

These are the influences that are a part of the structure of the church in its teaching and preaching functions. If church school teachers of the young have not come to a wholesome view of the nature and character of God, it is likely that their distorted views will be transmitted to their pupils. In the use of stories, Bible or otherwise, this is sometimes reflected when a teacher says, or implies, that "God doesn't like little boys and girls who . . ." The teacher of the nursery class has the most significant teaching position in the church school. Other classes may have more prestige, but none is more important. It is at this early age that children develop some of the concepts that can influence them throughout their lives.

Songs can also carry meanings to the child that have a powerful, negative influence. These words will likely bring

back some painful memories to some persons readings these lines:

> Be careful little hands what you do,
> Be careful little hands what you do,
> There's a Father up above
> Who is looking down in love,
> So be careful little hands what you do.

This song goes on to give warning to the eyes, the lips, and the feet. The message of the song is that God is the spy in the sky who is out to get people. How can a child accurately comprehend the contradictory messages of "there's a Father up above Who is looking down in love" with "so be careful little hands what you do"? It is not unlike the song "Santa Claus Is Coming to Town." The song warns youngsters they had better not cry or pout or Santa Claus, kindly old gent that he is, will pass them by, leaving them toyless while other children will make a haul.

There are earlier counterparts to this kind of portrayal of God. The following lines from this old song were well-calculated to put "the fear of God" in young hearers:

> Have ye not heard what dreadful plagues
> Are threatened by the Lord,
> To him that breaks his Father's Law
> Or mocks his mother's word?
> What heavy guilt upon him lies!
> How cursed is his name!
> The ravens shall pick out his eyes,
> And eagles eat the same.[4]
>
> —Isaac Watts

Who could hear those words and not be terrified at the thought of incurring the wrath of the Almighty?

C. S. Lewis said that a little girl reported that her family "didn't pray last night and nothing happened." Apparently something awful was *supposed* to happen on prayerless nights.

Preaching, as well as teaching, can sometimes convey an image of God that all but belies His nature and character. Well-intentioned, though uninformed sermons, aimed at effecting change through producing fear, guilt, and anxiety, often serve to point a picture of Providence that is not an accurate portrayal of His essential being. Thus, the hearers are left with a limited, and faulty, image of God.

Informal Influences

The strongest informal influence in the life of a child is his parents. If one's parents have not come to an adequate understanding of who God is, there is the likelihood that their faulty perception of God will be transmitted to their children. Unfortunately some parents instill a fear (not awe) of God in their children so as to control their behavior. Thus, their children can develop a dread of God rather than a love for Him. To control behavior at the expense of inflicting their children with a debilitating fear of God is to render them a disservice of the greatest magnitude. Some may never overcome such a fear of God. Children who have been victims of incest by their fathers may never resolve the theological and psychological effects caused by this kind of trauma.

Society, in general, has an informal influence in the shaping of one's view of God. This is reflected in jokes, cartoons, and other forms of humor. This is illustrated by a "gag gift" I once received from a family member. It is a picture of a golfer who, in the act of moving his golf ball to a more advantageous location, is instantly "caught" by the angry Almighty. The scowling face of Providence appearing through a cloud laced with lightning, along with a bony finger pointed like a loaded shotgun at the terror-stricken offender, leave no doubt as to its message: God's wrath is ready to be poured out on people at any moment and for any reason.

In television programs, both serious and humorous, negative images of God are often portrayed. One long-

running comedy, thankfully no longer being aired, often carried the line, "God will get you for that" when the leading character disapproved of what someone said or did. The teaching potential of television is both extensive and powerful, especially to the young. This powerful medium forms theology even when it is not attempting to do so.

In the reporting of news of disasters the news media will often record the victims' or near-victims' theology by statements such as, "It must have been the will of God." In the terminology of insurance policies, floods, fires, and tornadoes are referred to as "acts of God."

All of those informal influences, and many others as well, have a profound impact upon the development of one's image of God.

Biblical-Theological Perspectives

There are some biblical-theological issues that must be considered in this discussion. Is the gospel good news or bad news? Some view it as all bad news, leaving the impression that God is only concerned with judgment and punishment. Others view the gospel as only good news, leaving the impression that God is a marshmallow who is totally oblivious to sin. Both of these views are incorrect. The gospel *starts* with bad news but always *ends* with good news. It points out "the exceeding sinfulness of sin" clearly, boldly, and repeatedly, but it always ends on a positive note:

> But God, who is rich in mercy, for his great love wherewith he loved us, even when we were dead in sins, hath quickened us together with Christ, (by grace ye are saved;) and hath raised us up together, and made us sit together in heavenly places in Christ Jesus: that in the ages to come he might shew the exceeding riches of his grace in his kindness toward us through Christ Jesus. For by grace are ye saved through faith; and that not of yourselves: it is the gift of God: not of works, lest any man should boast *(Eph. 2:4-9).*

22

The apostle Paul expressed this truth again by stating that unredeemed man is dead in trespasses and sins but can be made alive with Christ by the power of God (Eph. 2:1-6). To be faithful to the biblical record, proper emphasis must be placed on both bad news and good news. To do one at the expense of the other is to emasculate the gospel.

The church is faced with the difficult, but achievable, task of walking the razor's edge, giving proper attention to both bad news and good news. We must speak appropriately of death and life in the same breath. That is, we must be faithful to scripture and thus to the nature and character of God, by showing that "where sin abounded, grace did much more abound" (Rom. 5:20).

When we think of the meaning of the gospel we are immediately confronted with the question of the nature and character of God. If He is a "great, big beautiful Doll," then that means that He is passive and uninvolved in human affairs. He is beautiful to behold but powerless to help.

That view does not do justice to Him, for He is identified with human needs and is deeply concerned with the human predicament. God is the parental archetype from whom we learn our own roles as parents. God could not stand impassively by, watching the disease of sin do its deadly work, any more than a parent could ignore the ravaging work of a deadly, but curable, disease in his child.

Man's volition must be considered here. Man has the power of choice and sometimes he chooses for sin. God also has the power of choice and He chooses for salvation. More than we, He knows the consequences of sin: ". . . when lust hath conceived, it bringeth forth sin: and sin, when it is finished, bringeth forth death" (James 1:15). But He does not force His choice on man.

Not to choose is to not be human. Without the power of choice, man is a brother to the brute beast. His power of

choice can be his crowning glory or it can be his greatest enemy. But choose he can, and choose he must, if he is to be truly human. To be truly human is to be able to choose either life or death. Moses said to God's people:

> I call heaven and earth to record this day against you, that I have set before you life and death, blessing and cursing: therefore choose life, that both thou and thy seed may live: that thou mayest love the Lord thy God, and that thou mayest obey his voice, and that thou mayest cleave unto him: for he is thy life, and the length of thy days: that thou mayest dwell in the land which the Lord sware unto thy fathers, to Abraham, to Isaac, and to Jacob, to give them *(Deut. 30:19-20).*

"Choose life" is the admonition, but if, instead, man chooses death, God's will is thwarted. He chooses to give man every opportunity to reverse his choice and be saved. A detached, uninvolved God? Indeed not. He has been, is, and always will be deeply identified with the human predicament. His involvement with the human race was incalculably costly to Him—it cost Him His only Son. The writer to the Hebrews said:

> In bringing many sons to glory, it was fitting that God, for whom and through whom everything exists, should make the author of their salvation perfect through suffering. Both the one who makes men holy and those who are made holy are of the same family. So Jesus is not ashamed to call them brothers *(Heb. 2:10-11, NIV).*

The costliness of God's love cannot be stated more succinctly than in these words, "For God so loved the world, that he gave his only begotten Son, that whosoever believeth in him should not perish, but have everlasting life" (John 3:16).

H. A. Ironside, in *The Continual Burnt Offering,* told of an old Welsh coal miner, a teacher of a Bible class, who gave his students liberty to discuss all biblical problems but often cautioned them with these words: "Whatever else ye do, lads, keep the character of God clear."[5] What a cogent admonition:

24

to keep God's character clear, to make of Him nothing more or less than the Bible reveals Him to be. The biblical record is this: God hates sin but He loves the sinner. When disaster struck Job's life, resulting in a devastating loss of wealth and loved ones, the biblical record is thus: "In all this Job sinned not, nor charged God foolishly" (Job 1:22).

Jean Baptiste Vianney said, "God will pardon a repentant sinner more quickly than a mother would snatch her child out of the fire." How true that is! Charles Haddon Spurgeon told of a man who had the text "God is love" inscribed above his weathervane because he wanted people to know that God is love whichever way the wind blew, that God's love is constant because He is constant.

Roy L. Smith said, "What a heavenly Father we have! He even attends the funerals of sparrows!"[6] So He does, for that is what God is like. J. Danson Smith wrote:

> *I cannot tell why life should thus be shorn,*
> *or heart thus emptied be:*
> *Why stricken, broken, desolate, forlorn,*
> *Should be my life's decree*
> *Yet—through my blinding tears I fain would trace*
> *The unchanged outline of thy tender face.*[7]

Not a few of us have had to overcome an unfortunate, negative image of God. By walking with God, studying His Word, being supported by His church, and being guided by His Spirit, I have come to an increasingly clear view of the nature and character of God. The older I have grown, the better God has become!

*

My God is reconciled;
His pard'ning voice I hear.
He owns me for His child;
I can no longer fear.
With confidence I now draw nigh,
With confidence I now draw nigh,
And, "Father, Abba, Father," cry.
—Charles Wesley

*

For you created my inmost being;
 you knit me together in my mother's womb.
I praise you because I am fearfully and wonderfully made;
 your works are wonderful,
 I know that full well.
My frame was not hidden from you
 when I was made in the secret place.
When I was woven together in the depths of the earth,
 your eyes saw my unformed body.
All the days ordained for me
 were written in your book
 before one of them came to be.
How precious to me are your thoughts, O God!
 How vast is the sum of them!
Were I to count them,
 they would outnumber the grains of sand.
When I awake,
 I am still with you.

—Ps. 139:13-18, NIV

3 Self-image and the Image of God

My experience as a counseling psychologist has led me to this conclusion: There is a significant correlation between a negative view of God and low self-concept. Caution and training

27

tell me to use the word *often* when referring to this correlation, but experience permits me to be more pervasive in my assessment. Almost without exception I find that persons who have negative views of God also have negative views of themselves. It might be of interest to speculate on the question of which comes first, a distorted image of God or a distorted image of oneself? That is not my concern at all. My concern is to try to help persons who are struggling in these two crucial areas to come to a newer understanding of both God and themselves. This will release them from the tyrannies of these traumas so that they can be at one with God and with themselves.

Psychologists concur that a low self-concept often reflects itself in feelings of alienation from others. When one cannot love himself appropriately, he assumes that others cannot love him either. If he does not experience self-acceptance, he finds it difficult to believe that he is worth loving. Paradoxically, these feelings can be experienced in the face of many facts to the contrary. It is not enough to be loved; one must feel worth loving before the message gets through. Worse than being unaccepted by oneself and others is to experience the triple threat of feelings of alienation from oneself, from others, and from God.

We are being deluged by love language in our day. The theme of love oozes out of the very pores of our society. It is in our prose, our poetry, and our music. It is in our minds constantly and on our lips almost daily. Much of this love language is really a cry to be loved. It is a hope more than it is a reality. Yet, love itself is not the last word. When love has been found and experienced, we have not reached the final goal. To be loved is not our ultimate need. Our ultimate need is to feel that we are worth being loved. That is why being loved is not sufficient. If the message of love is to be fully appropriated in the personal, subjective sense, one must feel worth being loved. This is true in both the human and the divine perspective.

I take strong issue with the "worm theology" that states that man is a creature of the dust who is positively worthless. There is, of course, a sense in which that is true—when comparing man, even at his noblest, with the holiness of God. In such a contest man is so far behind as to call him in second place is an insult to God. But it is also an insult to God to view man as a worm of the dust, for what does that say of the great God in whose image we are made? The worm theology learned from childhood has taken its toll on countless persons, leaving them with deep feelings of inferiority, inadequacy, and anxiety.

True, man's righteousness is as filthy rags. But man's unrighteousness cannot be equated with worthlessness. To do so is to commit a grave error, one that has serious spiritual and psychological consequences. It is at this very point that we see God's grace in all of its majesty. It has been said that God loves us as we are, but He loves us so much He will not leave us as we are. It is His grace that tells us that we are truly loved, and it is that grace that enables us to become what God intended us to be: persons who can lock arms with Him and walk in close, loving fellowship with Him.

The line of the much-sung song asks, "Would He devote that Sacred Head for such a worm as I?" Would Christ really have died for a worm? No. He went to the middle cross to die for us because He saw us as persons worth saving. A parent would give his life for a child but not for a worm. Christ gave himself for His own, children created in the image of the Almighty. He did not give himself for worthless worms.

We must have proper understanding of worth. The worth of man is not an achieved worth; it is a decreed worth. It is not what man has done that makes him worthy; rather, it is what he is, a being brought into existence by the Creator. Therein lies man's worth. Unless and until one recognizes this basic fact, appropriating it at both the level of the rational and the

29

level of the emotional, he will continue to struggle with feelings of worthlessness. To be unworthy is not the same as being worthless.

Feelings of worthlessness are too great a burden for any person to carry. While one may continuously assess himself as a nothing, or in some cases a *minus nothing,* there is, nonetheless, a strong desire to be of value. This results in trying to earn love by behaving in ways that are calculated to win the approval of the one we wish to love us. Psychologist Carl Rogers referred to this as "living under conditions of worth"; that is, to believe that one's worth is established by comforming to the wishes of others.

This is seen often in the behavior of small children—behaving as the parents wish in order to gain their approval and esteem. In adults the same procedure is employed, but in more sophisticated and subtle ways. The motivating factor, however, is the same, to earn love. In the next chapter we shall see how the attempt to buy God's love and to attain feelings of worth can develop into a theology of works.

Feelings of worthlessness can be experienced by persons who have no basis in fact for the low opinion they have of themselves. A young woman said to me, "I feel I have no right to use up oxygen that belongs to other people." This is lack of esteem to an extreme degree. God grants to even a toad a right to its fair share of oxygen, but this young woman could not see herself as being entitled to breathe the air that "belongs to other people." One might suspect that such a statement would come from a person who, by human standards, had little to offer. On the contrary, she was an intelligent, attractive young woman who was functioning well in her employment. This points out the paradox that often is a part of feelings of worthlessness: Such feelings can be experienced in the absence of fact to support the feelings.

Following are counseling notes taken during interviews with a young woman:

I am immature.
I am socially inferior.
I am unliked by my peers.
I am dumb and unlearned.
I am a poor piano player.
I am insincere.
I can't do anything well.

Another young woman made these negative self-assessments:

I don't know how anyone could stand to be around
 me *that* long (she was referring to marriage).
I don't have enough self-confidence.
I have hated myself since grade school.
I am depressed.
I feel sorry for myself.
I am lonely.
I *have* to grow up.
I like being by myself. No one's watching.
I can't accept constructive criticism.

If I Could Do Just *One* Thing

Based on the data supplied by these two persons, one would think that they had both started out in life at zero and had been steadily losing ground ever since. On the contrary, both were normal, intelligent, well-functioning individuals. The first was beautiful, sparkling, intelligent, and talented. The other was a professional person, functioning well in a responsible position. The facts, however, had nothing to do with their feelings. Their strong feelings of worthlessness persisted in spite of every reason to feel otherwise. This is a phenomenon that defies adequate explanation. I believe that millions of people are afflicted with this condition. Psychologists work with so many people who have an inferiority

complex that they almost long to meet a person with a superiority complex!

Below is a table that describes three types of self-concept. A study of it will reveal some of the major characteristics of these types of self-concept.

Types of Self-concept

I. *Underdeveloped*	II. *Overdeveloped*	III. *Realistic*
1. Sees self as *less* than one is	1. Sees self as *more* than one is	1. Sees self *as* one is
2. Self-depreciation	2. Self-elevation	2. Self-evaluation
3. Psychological sickness	3. Psychological sickness	3. Psychological wellness
4. Blurred boundary of being	4. Blurred boundary of being	4. Clearer boundary of being
5. Self-loathing	5. Over self-loving	5. Self-accepting
6. Unresponsive to extra-evidence of worth	6. Over-responsive to extra-evidence of worth	6. Open to extra-evidence of worth

In Type I, an underdeveloped self-concept, one sees himself as less than he is. This is illustrated by the self-assessments of the two women described earlier in this chapter. Such persons focus on their negative feelings about themselves and, to them, these feelings become reality. When persons hold such unfounded assumptions, they tend to function as they view themselves. In extreme cases they can lose so much self-confidence that even minor tasks become monumental endeavors.

The second aspect related to a low self-concept is that one tends to engage in psychological self-destruction. A continual put-down of one's self can result in psychological self-assassination. Such persons have existence but not life and, psychologically, they can become walking corpses. The wooden facial expression and the sagging shoulders of the deeply depressed person are evidences of this. Depression is often experienced by persons with a low self-concept; thus depres-

sion and low self-esteem feed each other, creating a negative, self-defeating syndrome.

Another result of a low self-concept is psychological sickness. There is a positive correlation between low self-esteem and emotional illness. The sickest persons, psychologically, are those with the lowest self-esteem. Exceptions to this might be some forms of psychosis, which are also illnesses.

A fourth characteristic of a low self-concept is that such a person has a blurred boundary of being. That is, he is increasingly less sure of who he is. He is only sure of one thing, that whatever he is, he is not much. Counselors, psychologists, and psychiatrists often hear their clients make these kinds of statements:

"I don't know myself anymore."

"I don't know who I *really* am."

"I don't understand why I do what I do."

These statements reflect loss of self-identity.

A fifth dimension of a low self-concept is that of self-loathing. Such persons literally come to despise themselves. They wish they were someone else, or, at times, they even wish they were dead.

Finally, a characteristic of a low self-concept is that one is unresponsive to extra-evidence of worth. That is, in spite of facts to the contrary, as well as positive assessments by others, they persist in their feelings of worthlessness. They label themselves as losers and continue to see themselves that way regardless of valid evidence to the contrary.

In Type II, an overdeveloped self-concept, there are also some distinctive characteristics that should be examined. First, one sees himself as more than he is. He gives himself more credit than he deserves and is more impressed by himself than the facts would warrant. Such overassessment results in self-elevation. Pride of "face, place, and grace" sets in and one becomes both his own hero and cheering section. My father used to tell of an acquaintance who viewed himself as a

33

"ladies' man." On one occasion he said to a friend, "Did you see that woman smile when she looked at me?" The friend said, "That's nothing—the first time I saw you I laughed out loud."

We are cautioned in the Bible not to think more highly of ourselves than we ought to think (Rom. 12:3). Self-elevation, like self-assassination, is a form of psychological sickness. Both are based on inaccurate assessments of worth. Let it be said, however, that there are more who suffer from lack of pride than from pride. I counsel so many people with low self-esteem that a bona fide, dyed-in-the-wool braggart would be a welcome change!

Excessive self-love characterizes the person with an over-developed self-concept. He can be described, someone has said, as "a self-made man who adores his creator." A prominent sports figure refers to himself as "the greatest." Once he got carried away and referred to himself as "the double greatest." Such a person is too responsive to extra-evidence of worth. That is, he is too quick to assume that external data regarding himself only begins to tell the real story of how great he is. Such a person can easily become self-centered. He believes that the universe began the Saturday night he was born. He becomes the center and the circumference of the universe. Here is a bit of verse that describes the self-centeredness of such a person:

> *I had a little teaparty this afternoon at three,*
> *'Twas very small, three guests in all*
> *Just I, myself, and me.*
> *I ate all the sandwiches while I drank up the tea,*
> *'Twas also I who ate the pie and passed the cake to me.*
> —Author Unknown

Type III, a realistic self-concept, is the goal toward which persons should be striving. A realistic self-concept helps one to see himself as he is. He is neither too quick to condemn himself nor too quick to praise himself. He is open to himself

and is capable of continuously evaluating himself with a reasonable degree of accuracy. He is a psychologically well person who is neither defeated by his shortcomings nor unduly impressed with his strengths. He has a clear boundary of being. He knows who he is. He can see his need to improve as easily as he can be appropriately pleased with his accomplishments. He accepts himself. This is not to say that he fully approves of everything he is and does. Such a person is open to extra-evidence of worth. This means that external data regarding himself, as well as assessments of worth by others, are processed by an objective view of himself.

Now all of this may seem to be a great digression from the theme of this book: a study of the psychological implications arising out of a negative image of God. On the contrary, I believe I am right on target. (Possibly this is because I have an overdeveloped self-concept!)

It was said earlier that low self-esteem and a distorted image of God often go together. Indeed, each may feed the other, making these negative views even worse. Both can become an ever-enlarging detriment to the other.

Of the three types of self-concept we have discussed, Type III, a realistic self-concept, is a Christian view. I believe that God is just as grieved with a person who lacks self-esteem (Type I) as He is with a person of pride (Type II). Both are unchristian.

Some persons are so biblically naive as to believe that a low self-concept can be equated with humility. Indeed, humility is one of the great Christian virtues, but humility is not the same as self-depreciation.

Let us look closer at how it can be unchristian to view oneself as being of no worth. Such a view ignores the fact that one is made in the image of God. That fact, in itself, makes every individual a person of infinite worth. We hear the expression these days, "God don't make no junk." What the statement lacks in grammar it more than makes up for in

theology. God doesn't make junk. Man is the highest of God's creation. That is an undeniable, biblical truth. That being the case, no person has the right to view himself as junk. It is interesting to note that some people's ethics are so impeccable as to never stoop to running down someone else, but they take neurotic potshots at themselves continuously. Is it Christian to loathe oneself? Is that really worse than loathing another? Both are God's creation and both are prized in the sight of God.

When counseling with Christians who run themselves down, I say, "It would help you if you would stop telling lies." This really shakes up the saints! After they recover I point out that running themselves down, in the absence of valid evidence, is a form of lying, and that one has no more right to tell lies on himself than to tell lies about another.

I pray that an epidemic of appropriate self-esteem will spread throughout the Christian Church. Too many Christians are like the 10 Hebrews who were sent to spy out the land of Canaan in order to see how God's people could conquer it. They brought a twofold dismal report from the land of the giants: ". . . we were in our own sight as grasshoppers, and so we were in their sight" (Num. 13:33). A low self-concept led them to believe that others viewed them as they viewed themselves.

For many Christians there is a "forgotten third" of Jesus' great commandment to love God with all one's heart and to love one's neighbor as oneself (Matt. 22:37-39). The love of self aspect gets garbled or lost somehow. There *is* such a thing as an appropriate self-love. Indeed, if one cannot love himself appropriately, he will also find it difficult to love God and his neighbor.

While self-love, in the biblical sense, and self-esteem are not equated, they are closely related operationally. Self-love, biblically, refers to the term *agape,* which carries with it a commitment of the will, to do for others what one would do

36

for oneself. (See Matt. 19:19; 22:39; Luke 19:25 ff.; Rom. 13:9-10; James 2:1 ff.; Eph. 5:25, 28, 33 as examples of this.) Self-esteem, on the other hand, is evaluative in its character. The word *esteem* is related to the word *estimate,* which means to assess value. Self-esteem, then, is attitudinal, not volitional.

Christianity is a highly personal religion. It is a personal encounter with God that reflects itself in relationships with others. Christianity is *the* interpersonal religion. Its focus is ever, and always, on relationships. These relationships are both vertical (God-man) and horizontal (man-man).

In the marketplace of relationships, both vertical and horizontal, the essential medium of exchange is a marketable (valuable) self. A valued self, freely given first to God and then to others, is at the heart of the Christian faith. The Christian faith rests on this kind of understanding. A proper self-esteem becomes the basis for both receiving God's love and giving God's love to others. These words of Jesus stand out in their beauty: Love God and love your neighbor as you love yourself.

*

For the love of God is broader
 Than the measure of man's mind;
And the heart of the Eternal
 Is most wonderfully kind.
 —Frederick W. Faber

*

Do you not know?
 Have you not heard?
The Lord is the everlasting God,
 the Creator of the ends of the earth.
He will not grow tired or weary,
 and his understanding no one can fathom.

<div align="right">—Isa. 40:28, NIV</div>

4 Religion and the Image of God

A negative view of God creates a distorted view of religion. The foundational element in any form of religion is how God is perceived. This is the reason why Dr. R. T. Williams said that his most profound impression from his world tour was how a people's conception of God could affect their entire lives. The one element that most differentiates the religions of mankind is how God is perceived. It is the foundation on which religious systems are built. To a large degree one's religion is an expression of one's perception of God. In *The Knowledge of the Holy,* A. W. Tozer said, ". . . man's spiritual history will positively demonstrate that no religion has ever been greater than its God."[1]

As one reads the Bible, it is clear that even among the peoples of the Judeo-Christian tradition there are great differences in their perceptions of God. It was said earlier that although there is one God, He becomes many Gods. Operationally and practically, the perceived God for any person becomes the "real" God. By the term *real* is meant what *seems* real to the perceiver.

It is a law of interpersonal relationships that people do not relate to each other as they are but as they are perceived. That is one reason why there can be so much conflict in interpersonal relationships. There can be an enormous gap between how one perceives another and how that person perceives himself. Thus, practically speaking, one individual can be two persons at the same time—how he sees himself and how he is seen by another. Of course, there is only one person, in the objective sense, but two "selves" emerge because there are two separate perceptions of that one self. From the viewpoint of interpersonal relationships, both of these selves are "real" in the sense that they are real to the perceiver and real to the one being perceived.

Not only can one's view of God shape the way a person relates to Him, but groups of people sharing similar perceptions of God can relate to Him on the basis of their collective perception. In this fashion religious systems develop and become formalized.

At one point in Israel's history her view of God had become both negative and crystallized. That view of God, though distorted, was real to the Israelites and their whole view of religion was influenced by it. The record of this is found in Micah 6:

> Hear ye now what the Lord saith; Arise, contend thou before the mountains, and let the hills hear thy voice.
>
> Hear ye, O mountains, the Lord's controversy, and ye strong foundations of the earth: for the Lord hath a controversy with his people, and he will plead with Israel.

O my people, what have I done unto thee? and wherein have I wearied thee? testify against me.

For I brought thee up out of the land of Egypt, and redeemed thee out of the house of servants; and I sent before thee Moses, Aaron, and Miriam. . . .

Wherewith shall I come before the Lord, and bow myself before the high God? shall I come before him with burnt offerings, with calves of a year old?

Will the Lord be pleased with thousands of rams, or with ten thousands of rivers of oil? shall I give my first-born for my transgression, the fruit of my body for the sin of my soul?

He hath shewed thee, O man, what is good; and what doth the Lord require of thee, but to do justly, and to love mercy, and to walk humbly with thy God? *(vv. 1-4, 6-8)*.

An examination of this passage will illustrate how crucially important a proper perception of God is.

Israel had been chafing under the yoke of religion. She had openly complained to God about His rigid requirements for their lives. God's response to this charge was that this controversy should be brought out into the open and settled objectively and fairly. Actually, God permitted himself to be placed on trial for His "crimes" against Israel. The mountains and the hills were to serve as the jury.

God proposed that two charges be settled in this court case. The charges were placed in question form: (1) "What have I done to thee?" and (2) "Wherein have I wearied thee?" These were the issues to be settled: (1) Was God requiring too much of Judah? and (2) In what ways were these requirements too demanding?

What an interesting situation—God and men airing this controversy before all nature, with the mountains and the hills serving as jurors to determine guilt. As an aside, let it be said that God tolerates, even accepts, man's anger at Him. He knows that man becomes hostile toward Him at times. Indeed, a sizeable portion of the psalms are called "lament psalms." Old Testament worship gave a large place to lament.

Lament, however, should always end in praise. It should culminate in a "praise God anyhow" attitude. Job's classic statement, "though he slay me, yet will I trust in him" ends with the words, "but I will maintain [argue] mine own ways before him" (Job 13:15). He also said he would "fill my mouth with arguments" with God and "dispute with him" (23:4, 7). Man and God have fussed frequently and both have survived the controversy, but God has always come out the winner!

The great questions to be answered in the controversy recorded in Micah were these: (1) "What is religion?" and (2) "What does religion require of its adherents?" Actually, both of these questions were related to the nature and character of God.

Before dealing with those two issues, God reminded Israel of how He had been at work in her history. He pointed out that His involvement in her history had taken three major forms. The first was that He had been their Deliverer: "I brought thee up out of the land of Egypt . . ." His second major involvement in her past was that he had been their Emancipator: "I . . . redeemed thee out of the house of servants . . ." Lastly, God reminded them that He had been their leader: "I sent before thee Moses, Aaron, and Miriam . . ." God had provided His leadership through three human instruments. One was Moses, representing the Law, another was Aaron, representing the priestly system, and another was the prophetess Miriam, representing the prophetic role. This leadership provided all that Israel needed in order for God's purposes to be achieved.

It would seem that Israel should have been ashamed to complain to God in the light of all that He had done. He had done so much for His chosen people. There can be no doubt that Israel knew all of this quite well. Every Israelite had been taught, from earliest recollection, how God had been at work in Israel's history. This was fully known and undisputable. Yet, all of this notwithstanding, Israel's *perception* of God was a

very distorted one. Instead of being a Benevolent One who had provided deliverance, emancipation, and leadership for His people, they saw Him to be both demanding and exacting in His requirements. The yoke of religion He placed upon them was too burdensome to bear, it seemed.

It is here that we can see there were really two Gods in existence at this point in Israel's history—the true God and the God of Israel's perception. These "two Gods" became the basis for two views of religion—God's and Israel's. Both God and Israel looked at the same thing—religion—but each saw something quite different. What Israel knew about God and what she felt about Him were two different matters. It was the latter, how Israel felt about God, that became the basis for the way she related to Him.

Israel's response to God's confrontation, believed by most scholars to have been an acknowledgment of her sin and need for atonement, is contained in a series of questions addressed to Him. These questions reflected an abysmal ignorance of the nature and character of God. Israel asked, "Shall I come before him with burnt offerings, with calves of a year old?" "Will the Lord be pleased with thousands of rams, or with ten thousands of rivers of oil?" That last question reached the ridiculous. Ten thousand rivers of oil is a lot of oil! But Israel's next question was the most serious misunderstanding about God. She asked, "Shall I give my firstborn for my transgression, the fruit of my body for the sin of my soul?" Israel was actually saying that she felt God's demands might be met if she engaged in child sacrifice for Him. Each question implied a sacrifice more costly than the preceding one. These questions received a negative response because each was totally removed from the character of God and from His view of religion. Here is God's view of worship: "For I desired mercy, and not sacrifice; and the knowledge of God more than burnt offerings" (Hos. 6:6). God does not want the worshiper's gifts: He wants the worshiper.

God had never required such sacrifices as Israel had outlined them. This was not what He had decreed Israel must do. True, He had endorsed the sacrificial system, as a foreshadowing of the great sacrifice by Christ that was to come, but never had He demanded what Israel *felt* He demanded.

How different is God's view of religion from man's view of religion! Man's perceptions of God have brought into existence all kinds of religions. Some of these have resulted in extreme forms of worship and ritual.

Over against Israel's faulty view of what God was, and what He required, is God's disclosure of himself and of His requirements. It can be found in verse 8, which has been called the "golden text of the Old Testament." It is a summary of the teachings of Amos, Hosea, and Isaiah. Here is God's grand disclosure to Israel (and to us): "He hath shewed thee, O man, what is good; and what doth the Lord require of thee, but to do justly, and to love mercy, and to walk humbly with thy God?" That is God's view of religion. How different it was from Israel's.

Who would want, or who could live with, Israel's view of religion? It was filled with duty and demand. It was harsh and exacting. Even the most drastic ritual, child sacrifice, might be required by God.

But God's view of religion is wholly different. It centers in doing justly, loving mercifully, and walking humbly with God. God's view of religion is three dimensional: doing justly —the extrapersonal aspect; loving mercy—the intrapersonal aspect; walking humbly—the interpersonal aspect, which expresses itself in a deep communion with God. God's view of religion is that we do justice, be compassionate, and walk with Him. We are to adopt the qualities that are the essence of God's character. He wants us to treat all persons fairly, to demonstrate His faithfulness, reliability, loyalty, and fidelity, and to be lovingly related to Him.

The apex of religion is the third dimension—walking humbly with God. To walk with God means that we are to do so with friendship, closeness, and intimacy. It suggests a continual association, the constancy of a bonded relationship. That was God's original intent for man and that has been His continuing intent for him. That is the way He related to Adam, the first man, and that is the way He wants to relate to every man.

That is the kind of religion man can live with. It centers in relationship; its focus is on love.

Israel's theology was a theology of works. It emphasized what she should *do* but omitted what she should *be*. There is a sense in which Israel was right in her charge that God would not be satisfied with abundant sacrifices, prolific oil-pouring, and child sacrifice. He would not be satisfied with all of that because that is not what He wants. God does not want anything man does or anything man has nearly so much as he wants man! He knows that if He has man, He has all that the man has and all that he is.

There are many Christians who, like Israel, have misperceived what religion is because they have misperceived who God is. Though their "paper theology" is a theology of grace, operationally it is a theology of works. When that happens the kernel is removed and only the shell remains. As Jesus stated in His denunciation of the Pharisees, "You load people down with burdens they can hardly carry" (Luke 11:46, NIV).

Back to the concept of "living under conditions of worth." As has been said, it is the attempt to buy love with behavior reckoned to please the one whose favor is desired. This is done by many persons in the realm of religion. This can be illustrated by this statement that was made to me:

> My perception of God is that of a harsh judge who is inclined to find the faults in my life and to keep track of them. This makes me more conscious of trying to do good

in order to even the slate. It is hard for me to accept the fact that God loves me unless I keep doing good things to merit that love.

What does all of this say? It says, "If I do better, and more, *then* God will love me." What a travesty on the nature and character of God! It reduces Him to a kind of evil, yet powerful, politician whose favor can be curried for a price.

God's love cannot be bought, it can only be received. It cannot be earned, only accepted. God's love is an *is;* it is not an *if.* St. John said it in its simplest form: "God is love" (1 John 4:16). Love is not an attribute that God has; love is what He is.

*

Ev'ry day the Lord himself is near me,
With a special mercy for each hour.
All my cares He fain would bear and cheer me,
He whose name is Counselor and Pow'r.
The protection of His child and treasure
Is a charge that on himself He laid.
"As thy days, thy strength shall be in measure,"
This the pledge to me He made.
—Carolina V. Sandell-Berg

*

I have chosen you and have not rejected you.
So do not fear, for I am with you;
 do not be dismayed, for I am your God.
I will strengthen you and help you;
 I will uphold you with my righteous right
 hand.

—Isa. 41:9-10, NIV

5 A God Too Heavy to Carry

There is a sense in which each person creates his own God.
This is so, of course, only in a psychological, not a literal,
sense. The God that we create becomes the God to whom we
relate, the One we attempt to serve.

To say that man creates God smacks of both audacity
and heresy because we know that it is He who created man.
The Bible was not yet one page in length before it recorded,
"Then God said, Let us make man in our image . . ." (Gen.
1:26, NIV). That decision was quickly followed by Divine ac-
tion: "So God created man in his own image" (v. 27). That is
the terse record of man's creation. This creation was the *first*
creation but, following that, there have been millions of cre-

46

ations. These are the creations that men have made of God. Each "little creation" has a profound impact on its creator because, to the degree that man creates Him, to that extent God is an inauthentic, inadequate, inferior God. An illustration from the time of Isaiah will be helpful in this discussion.

The making of a god, in Isaiah's day, was the work of a craftsman in his shop: "Some pour out gold from their bags and weigh out silver on the scales; they hire a goldsmith to make it into a god, and they bow down and worship it" (Isa. 46:6, NIV).

The gods that were created in Isaiah's day were helpless. Sometimes they were loaded on beasts of burden (Isa. 46:1), and sometimes they were carried by their creators (v. 7).

This kind of god, when transported to its appointed place, was stationary. It could not move; it remained where it was placed until its creators elected to move it: "They set it up in its place, and there it stands. From that spot, it cannot move" (v. 7, NIV).

The gods in Isaiah's day were also deaf. Such a god could not hear but that did not keep its creator from praying to it: "Though one cries out to it, it does not answer" (v. 7, NIV).

This kind of god was also powerless, "it cannot save him from his troubles" (v. 7, NIV). What a creation—a god who was helpless, stationary, deaf, and powerless. A god of man's creation! Instead of being helpless, God gives help to the helpless. Instead of being stationary, God is an initiating, seeking God. Instead of being deaf, His ear is always open to hear the prayers of His people. Instead of being powerless, God is all-powerful.

Man's workshop has never been able to produce a suitable god, though centuries of unsuccess at this endeavor have not lessened the attempts to do so. Man has not permitted his repeated failure to stand in the way of his continued ignorance. The history of man is a long record of his futile attempt at god-making.

Just as a god can be made in the workshop of a goldsmith, a god can also be made in the workshop of one's psyche. In either case, the product is inferior and inadequate.

A god created in one's psyche can be just as helpless, stationary, deaf, and powerless as the idols created in the time of Isaiah. It is not that God is really that way; rather, it is because He can be perceived as being that way. Functionally, to any given person, God is as He is perceived, and this perception determines the way each person relates (or does not relate) to Him. God, then, becomes a product of one's creation. Creating the Creator would seem an impossible thing to do but, on the contrary, it can be done with great ease, but always with great dissatisfaction.

When one creates God he also creates the kind of relationship he will have with Him. This is so because one's perceptions have so much to do with one's relationships. If God is perceived as being detached and unapproachable, one's relationship with Him will be, in Martin Buber's terminology, an I-It rather than an I-Thou relationship.

There is a paradox here. One's intellectual theology can be couched in personal terms, seeing God as a person, while at the same time one's "emotional theology" makes it virtually impossible to relate to Him in a personal, intimate, and meaningful way. God has made us for relationships, both with others and with Him. When this need for relationships is not realized, the result is feelings of aloneness and even estrangement. To know God and to be known by Him are man's great needs. One's faulty perception of God, however, can make this dual knowledge virtually impossible. Not by design, but by default, one guarantees for himself the very thing he does not want: a nonrelationship, or an inferior relationship, with God.

Earlier I referred to an exercise I have my students and/or counselees do, namely, to write a short, impromptu description of God based on their personal perceptions of Him. As was said, many of these persons report negative and distorted

images of God. Following that exercise I ask them to respond to several related questions. One of those questions is, "Are you comfortable in the presence of the God you have just described?" Many respond that they are not comfortable with Him. Some report that they are even terrified of Him.

Another question I pose is this: "Is it possible for you to please the God you have just described?" Again, many have reported that they could not possibly please Him.

All of this points to the trauma with which many are living. They truly want a personal, intimate relationship with God, but such a relationship becomes virtually impossible because of their debilitating perceptions of God.

The kind of creation I am referring to is a matter of how one feels about God. The term *felt concept* is appropriate to use here, for I am not referring to one's thinking about God but one's feeling about God. One's biblical-theological knowledge of God can actually be nullified by one's felt concept of God. Distorted and negative images of God are an oppressive load to carry, not unlike the idols of which Isaiah said, "The images that are carried about are burdensome, a burden for the weary" (Isa. 46:1, NIV).

To show how burdensome distorted and negative images of God can be, let us look again at some of the descriptions given of God that were listed in Chapter 1:

"His greatness, holiness, and power frighten me."
"He is always pushing me to do more than I am capable of doing."
"I am tempted to believe in His vindictiveness . . ."
"I am *so* afraid of God."

What a heavy burden! A God like that is too heavy to carry. Some who have had such a God have wanted to relieve themselves of the burden by trying to give Him up, only to discover that it cannot be easily done because He is being carried inside. Thus, the load is always there, so oppressively heavy as to cause a spiritual hernia. Such a God is a deity with

49

whom one cannot live, yet He is also a deity without whom one dare not die. This is the tension with which many are living. It is a no-win situation, a predicament from which there is no easy release.

In contrast to a God who is too heavy to carry is the God of the ages who described himself in these terms:

> I have upheld [you] since you were conceived, and have carried [you] since your birth. Even to your old age and gray hairs I am he, I am he who will sustain you. I have made you and I will carry you *(Isa. 46:3-4, NIV)*.

What a contrast! Instead of a God that is too heavy to carry, there is a God who *does* the carrying. He has done it since the time of man's infancy and will continue to do it until time is no more. The God who has carried us since our birth will sustain us until our death. The hymn "How Firm a Foundation" gives an authentically biblical description of God. None better can be found in all of Christian hymnology. It says:

> *E'en down to old age all My people shall prove*
> *My sov'reign, eternal, unchangeable love,*
> *And when hoary hairs shall their temples adorn,*
> *Like lambs they shall still in My bosom be borne.*
> *The soul that on Jesus hath leaned for repose,*
> *I will not, I will not desert to his foes,*
> *That soul, though all hell should endeavor to shake,*
> *I'll never, no never, no never forsake.*

A god to be carried or a God who carries—those are the options. The choice that is made will have a profound significance on one's life.

*

Guide me, O Thou great Jehovah,
Pilgrim through this barren land.
I am weak, but Thou art mighty;
Hold me with Thy powerful hand.
Bread of Heaven, Feed me till I want no more.
Bread of Heaven, Feed me till I want no more.

—William Williams

*

The Lord is near to all who call on him,
to all who call on him in truth.

—Ps. 145:18, NIV

6 Prayer and the Image of God

We will now turn to the matter of seeing the relationship between prayer and one's image of God. A negative view of God creates a distorted view of prayer. An example of this is reflected in the following statement a counselee made: "There are times when I don't feel right praying to Him, as if I don't deserve His ear."

It is a law of life that we tend to repeat satisfying experiences and that we tend to refrain from repeating dissatisfying experiences. This principle has a direct bearing on one's prayer life. Invalid views of both the nature of prayer and of the nature of God can result in deep disappointments and feelings of failure in prayer. In this chapter we shall examine some of those invalid views.

Some People Have a Wrong Concept of What Prayer Is

Prayer is often viewed in terms of duty; thus it becomes an unwelcome task, an obligation. To be sure, there is a sense in which prayer is the Christian's duty. One cannot read the

Bible's many emphases upon the place and importance of prayer without coming to a full realization that prayer is a duty of the Christian life. Also, a study of the prayer life of our Lord himself teaches us that if our sinless Savior regularly sought the secret place of prayer, we should do no less. Yet to view prayer wholly, or even chiefly, as a duty is to rob it of its meaning and to place it far down the scale of values in Christian experience. A young woman said to me, "Prayer is boring; like writing a letter home when nothing is happening." But seeing it as her duty, she prayed anyway.

There is a negative aura around the word *duty*. It carries with it a certain sense of oughtness that makes it seem as though it is a bitter pill to be taken because it should be done and it will be good for us. Seeing prayer only as duty places it within a negative framework, thus reducing it to an unpleasant performance or a dull routine.

By law, a man must provide for his family. Because of that, it might accurately be said that it is something that he must do. It is a duty that he must perform or legal action can be taken against him. All of that notwithstanding, it is a poor specimen of manhood who would grouse continuously about having to support his family. Can you imagine a man worth his weight in salt who would feel sorry for himself because he is caught between the unattractive alternatives of either using his resources to care for his family or go to jail if he did not?

While writing these words in a mountain retreat setting, I have been distracted often by a ground squirrel making repeated trips of over 100 yards, carrying provisions to her den. Not being conversant with the laws of ground squirrel society, I cannot be sure but I would assume that the little creature could be shot at sundown by her peers if she did not engage in all of that activity. Such a threat, however, does not seem to be the motivating force behind her behavior. Because she "loves" her family, she seems to be thoroughly enjoying what she is doing.

Similarly, if we see prayer as something that must be done it is shorn of both its beauty and its meaning. Prayer is not a cross to be carried, it is a conversation to be carried on. It is going to God because we want to, not because we have to. Duty is swallowed up by love when we are drawn by desire and not driven by duty.

Some Persons Have a Wrong Concept of What Prayer Does

Many people have the faulty notion that prayer serves as a means for getting visible and dramatic answers from God. Somewhere deep within is the belief that if one *really* prays, then visible and dramatic responses will come. Such a notion reflects a misconception not only about the nature of God but of the nature of prayer as well. The belief that something must "happen" sets up the petitioner for certain disappointment.

To be sure, God can answer prayer in startling and dramatic ways. Accounts of such can be found in both the Bible and in Christian history. Neither of these, however, is support for the belief that such responses will always come from God. The Bible does not promise us that this will regularly happen. Despite this, many Christians persist in that misconception, thus setting themselves up for disappointment and spiritual defeat.

God's usual response is not an unusual one. Things need not "happen" every time we pray. Sometimes they do but most of the time they do not. In Everette Howard's book *Miracle in Cape Verde,* the account is recorded that during an extreme drought on the island of Fogo, many lives were lost and other lives were being threatened. God's people prayed earnestly and desperately for Him to intervene. God responded by causing water to gush from a rock. I have been told that the stream is still flowing today. Did God really answer prayer in that dramatic way? There is no question about it. Yet, the same people who addressed God and received that miraculous and dramatic response have prayed countless

other prayers that were not answered in that manner. That poses a problem. Does this mean that God was less able to respond than before? Certainly not, for He is the same "yesterday and today and tomorrow" (Heb. 13:8, NIV). Were those that prayed the earlier prayer less Christian than before? Assuredly not. What is the answer to this conundrum? The best answer is that God has not promised that He will answer every prayer in a visible or dramatic way. To assume that He will do so is to guarantee deep disappointment with the prayer experience.

If prayer is not guaranteed to be answered in a dramatic way, is there something that can always be counted on? The answer is yes. Here is what it always does: Prayer always brings us into the presence of the great God in the universe, and we are the richer for the contact. Too often God is approached materialistically and mechanistically. He is sought for things, approached as one does a vending machine—a coin is inserted, a button is pushed, and a product is expected.

A little boy was asked if he said his prayers every night. He replied, "No, 'cause sometimes I don't want nothin'." O the self-centeredness of our prayers! It seems we can do our best praying, at least our most frantic praying, when some great physical or material need is faced. It is like the man who reported that his most urgent praying was done when he was standing on his head in a dry well into which he had fallen! Going to God for what He can do for us, rather than for what He is, results in a greater impoverishment because we have not sought Him, we have sought only His benefits. Augustine said, "The reward of God is himself."

This does not mean that we should not pray for material needs. Jesus himself taught us to ask our Father for daily bread. There is nothing wrong with praying for material needs, unless that is the only kind of praying that is done.

A minister-friend of mine said that in one of his pastorates his study was located at the parsonage. His small son

often bolted through the study door to make repeated requests of his father. One day, after one of many interruptions, the father sternly said to the little fellow, "What do you want this time?" The little lad replied, "I don't want nothin'. I just want to be wiff you." What a pleasant change for Providence if, at least on rare occasions, we would come into His presence "just to be with Him." That is the prayer of communion, which is the highest form of prayer.

I have a wealthy friend who has given me many gifts. The Bible that is before me as I write these lines is one of many expressions of his generosity and kindness to me. My appreciation for him, however, is not predicated upon what he has given me. Indeed, we were friends long before he acquired wealth. Though a half a continent separates us, I often wish I could visit him, not in order to receive something from him but to just be with him. I have been his beneficiary many times, but the gift of his friendship is his greatest gift to me. Similarly, while God can and does shower His blessings on us daily, our greatest wish should be that He would grant us himself.

Some People Have a Wrong Concept of What God Is

Some people do not have an understanding of the essential nature of His character. It may seem presumptuous to attempt to determine what He is, and in the fullest sense, it is; however, St. John, under the inspiration of the Holy Spirit, dared to make such an assessment. He declared, "God is love" (1 John 4:16). Love is His essential nature. As was said earlier, love is not something God has, love is what He is.

If God truly is love, that has everything to do with how He can be approached. This means that God is neither unapproachable nor unreachable. It means that we need not fear to come to Him. It means that His arms are outstretched, that He wants us, yes, even invites us, to come to Him. It is at this point that we return to the thesis of this book; namely, that

our perception of God determines the nature of our relationship with Him.

Once I heard a woman in her 50s make this statement: "I just realized for the first time that God loves me." As she spoke she emphasized the word *me*. Was this the ecstatic expression of a new Christian? No, she had been a Christian most of her adult life. She was a graduate of a Christian college and had been employed in a religious institution for many years. Most of her life she had lived with the cleavage between what her mind knew and what her emotions felt. Knowing that God loved her did not make it a reality at the level of her emotions, her "felt concept" of God.

A young lady whom I had been counseling came into my office one day bubbling with excitement and said, "Guess what? I just found out that the first spiritual law is true!" (The first spiritual law is a part of Campus Crusade's witnessing program which says, "God loves you and has a plan for your life.") The reality of her own salvation had just broken through to the level of her emotions. The turning point in her Christian pilgrimage centered in an inner realization of the nature and character of God, that because God *is* love He loved *her.*

If God is love, that has everything to do with how He can be approached. God carries no club. There is no angry scowl on His face. His arms are not defiantly crossed signifying that He is an unapproachable God. On the contrary, He is a smiling God with open arms who beckons us to himself. It is no wonder that the writer to the Hebrews could declare that we can "come boldly unto the throne of grace, that we may obtain mercy, and find grace to help in time of need" (4:16).

Come *boldly* to the great God of the universe, who spoke life into existence, who created the heavens and the earth, and who holds a billion worlds in the palm of His hand? Yes, indeed, because behind all that God can *do* is the God who *is.* Galileo said that the sun that holds the stars and planets in

their orbits also has time to ripen a bunch of grapes on the vines of Italy. The great God, who is the Maker and Sustainer of all things, prizes nothing in His universe nearly so much as He prizes us. Let this grand truth saturate our total being: God is love and He loves us.

These three questions have everything to do with the prayer experience: (1) What is prayer? (2) What is it that prayer does? and (3) What is God? The answers are: (1) Prayer is a conversation with God; (2) Prayer always brings us into the presence of the great God of the universe, and we are richer for the encounter; and (3) God is love.

It was stated at the beginning of this chapter that we tend to repeat satisfying experiences and refrain from repeating dissatisfying ones. Keeping clearly in mind what prayer is, what it does, and what God is, will make prayer the rich and rewarding experience that we want it to be and that God intends it to be. The chorus of the song "In the Garden" captures the beauty and essence of the relational aspect of prayer in these words:

And He walks with me, and He talks with me,
And He tells me I am His own,
And the joy we share as we tarry there,
*None other has ever known.**
—C. Austin Miles

Jesus taught us many wonderful things, but one of the greatest was how to talk to God. He taught us to pray, "Our Father . . ." The word *our,* in that connection, is one of the grandest words known to man. When Jesus taught His disciples to pray "Our Father . . . ," He was telling Christians of their status as well as their privilege. Their status is that of being children of the Father. Their privilege is that of being

able to approach Him without fear and in love. Isaiah, caught up in the wonder of the Almighty, wrote these beautiful words:

> Hast thou not known? hast thou not heard, that the everlasting God, the Lord, the Creator of the ends of the earth, fainteth not, neither is weary? there is no searching of his understanding. He giveth power to the faint; and to them that have no might he increaseth strength. Even the youths shall faint and be weary, and the young men shall utterly fall: but they that wait upon the Lord shall renew their strength; they shall mount up with wings as eagles; they shall run, and not be weary; and they shall walk, and not faint *(Isa. 40:28-31).*

The God who does not faint and who does not become weary gives strength to His children who do become faint and weary. His strength is given for their weakness. It comes by waiting upon the Lord, by going to Him in faith believing that He is able and willing to do more than we ask or think (Eph. 3:20). John Baille marveled at this glorious truth by declaring:

> I bless thee, O most holy God, for the unfathomable love whereby thou hast ordained that spirit with spirit can meet and that I, a weak and erring mortal, should have this ready access to the heart of Him who moves the stars.[1]

✳

Neither life nor death shall ever
From the Lord His children sever;
Unto them His grace He showeth,
And their sorrows all He knoweth.
—Carolina V. Sandell-Berg

✳

Where can I go from your Spirit?
 Where can I flee from your presence?
If I go up to the heavens, you are there;
 if I make my bed in the depths, you are
 there.
If I rise on the wings of the dawn,
 if I settle on the far side of the sea,
even there your hand will guide me,
 your right hand will hold me fast.

—Ps. 139:7-10, NIV

7 The God Out There

It is possible for one to be earnest in his faith and diligent in his service while at the same time holding crippling concepts of Christianity. These concepts are often centered in three major areas. In this chapter we shall deal with those three conceptual frameworks.

Adolph Meyer, formerly a psychiatrist at Johns Hopkins University, said, "The trouble with most people is not that they are ignorant; they just know too much that isn't so."

Unfortunately, many Christians are certain of some things about God and Christianity that will not hold up under the weight of biblical evidence. Notwithstanding, these misconceptions are tenaciously held in spite of biblical evidence to the contrary. Let us look at three of these commonly held misconceptions.

Fallacy No. 1: God Is "Out There"

It is surprising how many Christians hold the misconception that God is somewhere "out there" rattling around in His universe. Their knowledge of theological geography is abysmally lacking.

The question may be asked, "Isn't God out there, and everywhere, in His universe?" The answer is yes if we are referring to His omnipresence. Omnipresence means that God is everywhere at all times. God's omnipresence, coupled with the fact that He is a spirit, tells us that, indeed, He is "out there." For the Christian, however, this knowledge about God is not sufficient, for it makes Him both unreachable and unrecognizable. If God is viewed as only an omnipresent spirit, without subscribing to Him other qualities and attributes, He becomes remote and abstract.

For the Christian, God cannot be "out there" and still be the knowable God. God must never be perceived as "out there" but "in here," not in the heavens but in the heart.

It may seem to some that I am straining at a point, possibly even setting up a straw man in order to knock it down. Remember, however, that I am not talking of "paper" theology but of operational theology. I am not dealing with what Christians know about God but what some of them feel about God. In the objective sense every born-again Christian knows that God resides in the human heart. Yet this knowledge is not always fully appropriated in the subjective sense.

Think for a moment about the content of some public prayers. One cannot attend many worship services without

hearing a prayer that says, "O God, come and . . ." Come? From where? Presumably from "out there." Such prayers not only reflect an ignorance of the geography of God, but they also often assume that "out there" is *way* out there," based on the loudness of the prayers.

When hearing such prayers, one is reminded of the frantic incantation of the priests of Baal in Elijah's day who were praying for the sacrifice to be consumed. There is more than a little earthy humor in Elijah's taunting, which said, in effect, "Pray a little louder, Baal may be talking, or in the outhouse with the door closed, or on a vacation, or sleeping" (see 1 Kings 18:27).

Many prayers express a negative view of the nature and character of the God "out there." Based on the content of some prayers, one would have to assume that the God "out there" not only is far removed from the human scene but also is little concerned with it. Thus, He is pleaded with repeatedly to "come and help us." Such praying suggests that God is a reluctant Deity who keeps us dangling until He is finally convinced that we need Him.

But what about private prayers? Is not the same mind-set reflected here as it is in some public prayers? Unfortunately, it is. The most urgent and desperate prayers offered either in public or in private often reflect ignorance about God.

Where *is* God anyway? For the Christian He is one place and *one place only.* He is in the heart. Wherever the Christian is, God is. Jesus stated this divine design as follows: "Behold, I stand at the door, and knock: if any man hear my voice, and open the door, I will come in to him, and will sup with him, and he with me" (Rev. 3:20). God is resident in the Christian's heart; to the non-Christian He is no farther away than the threshold of the heart. Only in the latter sense can God be properly referred to as being "out there."

The apostle Paul stated this great truth in the grandest style as follows, ". . . Christ liveth in me" (Gal. 2:20). Marion

Lawrence said, "The heart of religion is the religion of the heart."

Knowing where God is, and acting upon that knowledge, saves us from the fallacy of thinking and behaving like the heathen who assume that God is residing somewhere beyond the range of human concern. God is not a faraway God.

Fallacy No. 2: Religion Is Keeping Rules

It is possible for a Christian to keep all the rules and still know nothing of the intimacy of a personal relationship with God. The rich young ruler kept all the rules but still was lacking in spiritual perspective. Some Christians equate rule-keeping with spirituality. This was the error of the Pharisees. Their record of rule-keeping was impeccable; yet, Jesus referred to them as tombs who were beautiful on the outside but full of decay and death on the inside. They were regular "churchgoers," consistent tithers, and strict Sabbath-keepers, but no group received a more scathing denunciation from Jesus. Had rule-keeping met the demands of deity, the Pharisees would have been at the head of the class. Their error was assuming that legalism and spirituality were synonymous.

Christians, too, can make this error in judgment. Some feel that if their list of prohibitions is long enough, they are assured of being counted among the spiritual elite. To assume that one is a Christian solely on the basis of what he does not do is to reveal great biblical ignorance. If it could be reduced to that level, it would be possible to be a Christian without the benefit of the grace of God and the crucifixion of Christ.

It should go without saying that a case is not being made for breaking rules, nor am I suggesting that the ethical dimension is not important in Christian living. There are rules for Christian living and these rules must be kept; however, no amount of rule-keeping, in itself, will produce a Christian character. The attempt to equate the two is nothing short of Pharisaism.

Fallacy No. 3: Religion Centers in "Doing"

Again, our operational theology can sometimes belie our "paper theology." We can fall into the error of believing that we will be good enough if we do enough. It is possible to know that we are saved by grace and not works, yet proceed to live out our lives on a works basis.

Like a politician who says, "I stand on my record," we often approach God on the same basis. We recount what we have done for Him in the belief that we, in return, are entitled to something from Him. This shows up acutely in prayer when we preface a petition by reminding the Lord that our tithes are paid in full and that we have been faithful in attending the means of grace. Even a longer-than-average Sunday School attendance pin seems to give a certain ring of authenticity to our mighty deeds of Christian valor.

Such a view of Christianity is contractual in character, reducing it to the level of bargaining with God. Christianity is not collecting stamps that can be turned in at the redemption center for some special prize. If it were, our religion would be reduced to a kind of spiritual capitalism that would reflect a "what's-in-it-for-me" attitude.

The God Who Can Be Known

To say that God can be known by the human mind needs some qualification. To know God does not mean that we can know all there is to know about Him. This can be illustrated with the following story: One day St. Augustine was walking along the seashore in quiet meditation. His thoughts were centered on the doctrine of the Trinity, trying to comprehend how God could be three, yet one. His attention was drawn to a little girl, playing in the sand of the beach, who was carrying a shovel full of water to a little hole she had dug.

"What are you doing?" he asked. She replied, "Oh, I am going to empty the sea into this little hole I've dug."

The great theologian smiled and said to himself, "I am trying to do exactly what that little girl is doing—trying to crowd the infinite God into this finite mind of mine."[1]

Fortunately, we do not have to fully understand God in order to receive His love for us. Were that the case, no one would ever be the recipient of God's boundless love. Were we able to reduce God to the dimensions of our mind, we would then have a God who is too small to help us. Faith dares to trust the truth of God as recorded in His Word. As Charles Haddon Spurgeon said, "Faith is taking God at His word. Faith is not belief without evidence." Nor is faith equated with feeling. That is the error that countless millions have made. To reduce God to the dimensions of our emotion is as erroneous as reducing Him to the dimensions of our reason.

The God Who Can Be Trusted

Once Martin Luther was asked, "When the whole world turns against you—church, state, princes, people—where will you be then?" He said, "Why, then as now, in the hands of the Almighty God."[2]

God can be trusted. Trust in God is based on the truth revealed about Him in the Scripture and confirmed in sacred history. In Micah 6:8, the words "He hath shewed thee, O man, what is good" refer to God's demonstrated activity in Israel's history. God's record of faithfulness is impeccable. He was not "out there"; He was with Israel through her history.

Years ago I read of a man in the northern woods who came to a frozen lake he needed to cross. Fearing that the ice might be too weak to bear his weight, he carefully laid down in order to distribute his weight on it. He then painstakingly inched his body over the ice. He had almost reached the other side when he heard a noise behind him. He turned to see a man on a wagon-load of wood being pulled by a team of horses! Faith, based on feeling, is like that. Our tentativity in trusting God is a judgment against our lack of faith, not an

assessment of the nature and character of God. He is a God who is "a very present help in trouble" (Ps. 46:1).

I have heard testimonies of people who were in great distress that ended like this: "All I had left was God." The implications were that only having God was to be living on the ragged edge of nothing. It would be hard on our feelings, but good for our souls, if we would be shorn of everything but God so that He could demonstrate to us, as He has done countless times in human history, how adequate He is to meet our needs. Paul said, "But my God shall supply all your need according to his riches in glory by Christ Jesus" (Phil. 4:19).

The Psalmist said,

> One generation shall praise thy works
> to another, and shall declare thy mighty acts. . . .
> The Lord is gracious, and full of compassion;
> slow to anger, and of great mercy.
> The Lord is good to all: and his tender
> mercies are over all his works. . . .
> The Lord is nigh unto all them that
> call upon him, to all that call upon him
> in truth *(Ps. 145:4, 8-9, 18)*.

Peter said that we can cast all our care upon Him because He cares for us (1 Pet. 5:7). Our cares become His care! His love is granted to all of His children, without regard to condition or circumstance.

Bruce Larson told of a schoolteacher who had two small boys in her class who had the same last name but who were quite different in appearance. When she asked if they were brothers, one said, "Yes, but one of us is adopted, and I forget which one."[3] We have been adopted into the family of God. So great is His love for us that He treats us no differently than His own dear Son.

A story is told of an old Scottish woman who was alone much of the day. She was asked what she did during the day. She replied, "Well, I get my hymn book and I have a little

hymn of praise to the Lord." Then she added, "I get my Bible and let the Lord speak to me. When I am tired of reading, and I cannot sing any more, I just sit still and let the Lord love me." She had found the truth that all of us need to know, that God's love is available for all who will receive it. God's love is not granted capriciously; it is granted constantly.

In Psalm 136 the Psalmist chronicled the unfailing love of God for His people. In 26 verses he recorded the many ways in which God has evidenced His love for His people. Each of those verses ends with the same words, "for his mercy endureth for ever." Look at God's unfailing record:

O give thanks unto the Lord; for he is good: for his mercy endureth for ever.

O give thanks unto the God of gods: for his mercy endureth for ever.

O give thanks to the Lord of lords: for his mercy endureth for ever.

To him who alone doeth great wonders: for his mercy endureth for ever.

To him that by wisdom made the heavens: for his mercy endureth for ever.

To him that stretched out the earth above the waters: for his mercy endureth for ever.

To him that made great lights: for his mercy endureth for ever.

The sun to rule by day: for his mercy endureth for ever.

The moon and stars to rule by night: for his mercy endureth for ever.

To him that smote Egypt in their firstborn: for his mercy endureth for ever.

And brought out Israel from among them: for his mercy endureth for ever.

With a strong hand, and with a stretched out arm: for his mercy endureth for ever.

To him which divided the Red sea into parts: for his mercy endureth for ever.

And made Israel to pass through the midst of it: for his mercy endureth for ever.

But overthrew Pharaoh and his host in the Red sea: for his mercy endureth for ever.

To him which led his people through the wilderness: for his mercy endureth for ever.

To him which smote great kings: for his mercy endureth for ever.

And slew famous kings: for his mercy endureth for ever.

Sihon king of the Amorites: for his mercy endureth for ever:

And Og and king of Bashan: for his mercy endureth for ever.

And gave their land for an heritage: for his mercy endureth for ever.

Even an heritage unto Israel his servant: for his mercy endureth for ever:

Who remembered us in our low estate: for his mercy endureth for ever:

And hath redeemed us from our enemies: for his mercy endureth for ever.

Who giveth food to all flesh: for his mercy endureth for ever.

O give thanks unto the God of heaven: for his mercy endureth for ever.

The Psalmist was overwhelmed with the lovingkindness of God. He said,

How precious also are thy thoughts unto me, O God! how great is the sum of them! If I should count them, they are more in number than the sand: when I awake, I am still with thee *(Ps. 139:17-18).*

The God "out there"? Indeed not.

*

Great is Thy faithfulness, O God, my Father;
There is no shadow of turning with Thee.
Thou changest not; Thy compassions, they fail not;
As Thou hast been Thou forever wilt be.†

—Thomas O. Chisholm

*

When you pass through the waters,
 I will be with you;
and when you pass through the rivers,
 they will not sweep over you.
When you walk through the fire,
 you will not be burned;
 the flames will not set you ablaze.

—Isa. 43:2, NIV

8 Lonely Christians

The two words in the title of this chapter—*lonely* and
Christians—should be imcompatible terms. That is, there
should be no lonely Christians in the world but, in truth, there
are many of them. That there are lonely Christians in the
world is a tragedy for them and a charge against the churches
of which they are a part.

　　Much has been written about the subjects of depression,
guilt, and anxiety but comparatively little has been written
about loneliness. There has been a noticeable lack of the latter
in Christian literature. It is difficult to explain why depres-
sion, guilt, and anxiety get so much emphasis, and loneliness
so little, when loneliness lies at the heart of the other three
human experiences. Loneliness is a hazard of human exis-
tence. After God had created Adam He saw that it was not

good for him to be alone, so He created a companion for him (see Gen. 2:18). People need people.

Many persons, including an inordinate number of Christians, are living in what Viktor Frankl calls an existential vacuum.[1] Life for these persons has lost its meaning and there is no apparent reason for one's existence. Such persons are often deeply depressed, guilt-laden, and anxiety-ridden. Their loneliness is almost unbearable, resulting in a kind of existential anxiety. Their feelings of isolation are persistent and almost pernicious.

The Development of Personality

For decades psychologists have given themselves to the study of personality development, how and why persons have come to be as they are. Earlier psychology tended to put the individual under a microscope in order to study him in bits and pieces. Such a study involved isolating individual traits and characteristics and examining them in great detail. Later psychology, while not ignoring these minute aspects of personality, has given a greater emphasis to the study of man in his life situation, focusing especially on the importance of one's interpersonal relationships as a major determinant in the development of personality. Selfhood, to the later psychology, is far more than a conglomeration of individual traits and characteristics; rather, selfhood has come to be understood as the sum of one's characteristics, the sum of one's life experiences and relationships plus the value of all of this as it has been assigned by the individual himself. Thus, the self-evaluative aspect is believed to have a large role to play in the development of selfhood.

Selfhood defies definition. At best it can only be described. Albert Camus said that mystery cannot be removed from selfhood and that a design of selfhood is legitimate only in precisely so far as it is approximate.[2] Wayne Oates concurs

by observing that an assessment of selfhood is valid only as it is recognized as proximate.[3]

Personality might be described as the totality of one's characteristics, behaviors, experiences, and relationships, plus the valuing process that one employs in regard to oneself. All of this is to say that man is not an isolate, a gob of goo suspended in nothingness; rather, he is a self-conscious and self-evaluative being. His self-conscious and self-evaluative capacities are especially sensitive and active in his relationships.

Wayne Oates said,

> None of us is a psychological Melchizedek, sprung into existence full-blown without mother or father. Each person by empirical circumstances is born into a different station in life from any other person, although the grosser commonalities of geography, family name, or race may be roughly the same.[4]

My three brothers and I share these commonalities of which Oates spoke, yet each of us is quite different, a fact for which all four of us are profoundly grateful. Why are we different? That is explainable for many reasons, not the least of which are the self-conscious and self-evaluative qualities mentioned earlier.

Now all of this may seem to be a departure from the theme, "Lonely Christians." Indeed, it is not a departure, for an awareness of some of the aspects of personality development, which I am here referring to as selfhood, has much to say about why persons, including Christians, can experience loneliness. The self-conscious and self-evaluative attributes figure in prominently in the development of feelings of loneliness.

If a person has come to be what he is largely as a result of his relationships and of his awareness of his identity and value in those relationships, we can now see how some persons can become unutterably lonely. To want to belong is a strong hu-

man need, as is the need to be separate. Belongingness and separateness are to some degree antithetical. That is, our need for belongingness, our need to be loved, sometimes is not fulfilled because of our need for separateness, our need to protect ourselves from vulnerability. One's acute recognition of his vulnerability, the capacity for being rejected and hurt, is sometimes the factor that causes one to withdraw from the very relationships he needs and craves. Intimacy is sacrificed for the sake of safety.

In a healthy personality belongingness and separateness can coexist in a satisfactory and fulfilling manner. The psychologically healthy individual enjoys both his need for belongingness and his need for separateness. This is so because he is on good terms with himself and with others. His self-esteem enables him to be at ease with others and at ease with himself. His healthy self-concept gives him a clear self-identity, and he can accurately assess his value in relationships just as he can assess his value as a psychic entity apart from others.

Not all persons, however, have healthy personalities. Many experience low self-esteem. Christians are not automatically excluded from that group. Such persons can be lonely, unbelievably lonely. The almost-constant companion of loneliness is depression. Much of depression is tied to relationships, either faulty relationships or the absence of relationships.

To say that depression is often relationally based is not to explain all depression in terms of the relational rationale. Indeed, recent research is discovering that there is a strong correlation between biochemical inadequacies and clinical depression. Whether there is a connection between the biochemical aspect and the relational aspect has yet to be determined.

For our purposes, here in this chapter, we are considering the kind of depression that has a relational component. That

this component exists as a part of depression is not denied by either the psychological community or the medical community. Both communities recognize the importance of this relational component in depression, disagreeing only in terms of its degree of importance.

Let us return to the theme, "Lonely Christians." It would be a great surprise to many church people if they knew that many of their own number were experiencing loneliness. Some, of course, cannot hide their loneliness because it is so obvious. It is reflected in their appearance, in their behavior, in their body language, and in their conversation. Others, however, who are just as lonely have become expert at concealing it. Not wanting to appear lonely or depressed they have learned to hide their feelings by adorning themselves with an all-is-well demeanor. They force themselves to smile, to be upbeat and confident, in the attempt to hide how they really feel about themselves. To the casual observer some of these lonely Christians are viewed as being happy and well-adjusted.

To assume that such persons are inauthentic, or even devious, is to underestimate the need to belong, to matter. Some lonely Christians carry the added burden of believing that if one is truly a Christian, he should never be depressed or lonely. These persons may even psychologically deny their loneliness and experience what is called "smiling depression." To want to belong, to matter, is to be human. To want to hide the fact that one feels he does not belong and does not matter, is also human. Human, but not sinful.

The Need for Relationships

Here is a piece of literature that describes in perfect detail the feelings of the lonely Christian:

I Wear a Thousand Masks

I hope you won't be fooled by me, for I wear a mask.

I wear a thousand masks, masks that I'm afraid to take off, and one of them is me.

I am likely to give you the impression that I'm secure, that confidence is my name and coolness my game, that the water's calm and I'm in command and that I need no one. But I hope you won't believe me.

My surface may seem smooth . . . beneath I dwell in confusion, in fear, in aloneness. But I hide this. I panic at the thought of my weakness and fear of being exposed. That's why I frantically create a mood to hide behind, a nonchalant, sophisticated facade to shield me from your understanding. But such understanding is my salvation. My only salvation. And I know it.

If I don't keep the mask in front of myself, I'm afraid you'll think less of me, that you'll laugh, and your laugh would kill me.

So I play the game, my desperate pretending game, with a facade of assurance without, and a trembling feeling within. And so my life becomes a front. I idly chatter to you in the suave surface tones. . . . I tell you everything that's nothing, and nothing of what's everything, of what's crying within me. So when I go into my routine, I hope you won't be fooled by what I'm saying. I hope you listen carefully to hear what I'm *not* saying.

I dislike the superficial, phony game I'm playing. I'd really like to be open, genuine, and spontaneous. I want your help in doing this. I want you to risk approaching me even when that's the last thing I seem to want, or need. I want this from you so I can be alive. Each time you're kind and gentle and encouraging, each time you try to understand because you really care, my courage to risk sharing myself with you increases.

I want you to know how important you are to me, how you can be a creator of that person that is me if you choose. But it will not be easy for you. A long conviction of worthlessness leads me to maintain distance.

The nearer you approach me, the blinder I may strike back. It is self-defeating but at the same time it seems the safest thing to do. I fight against the very things that I cry out for. But I am told that empathy is stronger than walls

and therein lies my hope. I desperately want you to under-
stand me in spite of my distancing tactics.

Who am I, you may wonder? I am someone you
know very well. I am every man and every woman you
meet.

—Author Unknown

The writer of this piece of material describes exactly what
I have been trying to say, that the need for relationships, to
belong, can be obliterated by the need to protect oneself. The
sentence "A long conviction of worthlessness leads me to
maintain distance" tells the whole story. The negative self-
evaluative process has done its deadly work, leaving one with
the feeling that he does not matter, that he does not belong.
This becomes the basis for loneliness.

Samuel Shoemaker has rightly observed that we are not
lonely because we are not loved but because we do not love.[5]
In similar vein it has been said that we are lonely because we
build walls instead of bridges. Both of those observations are
true. To assume, however, that the lonely person can conquer
his loneliness on the basis of the intellectual awareness that he
needs to do so is to underestimate the power of one's emo-
tions.

The Need for Self-revelation

John Powell has said that it takes the rawest kind of cour-
age to disclose ourselves.[6] How true that is. It does take raw
courage for many persons to dare to come out from behind
their protective walls. For some, the conquering of loneliness
will necessitate the exercising of a volition to do so in spite of
an almost overwhelming and debilitating fear of rejection.
Psychologist Sidney Jourard said that people become candi-
dates for psychotherapy because they do not disclose them-
selves in some optimum degree to people.[7] He also said that
healthy personality will display itself in the ability to make

oneself fully known to at least one other significant human being.[8] I fully concur with these observations.

An illustration of what Sidney Jourard was talking about was Lucille, one of my counseling clients. She was an attractive, well-educated, highly intelligent person who lived alone, worked alone, and hurt alone.

Her loneliness was overwhelming. Her low self-esteem had become her prison. To add to the trauma, her God was vindictive and unapproachable, which made her attempt at living a Christian life an almost intolerable burden. Even going to church was a painful experience. Her sense of alienation from herself, from others, and from God made her one of the loneliest people I have ever known. It was this overwhelming feeling of loneliness that forced her to come for counseling, even though to do so was a painful and frightening experience. Once she wrote me telling me of what a traumatic experience her counseling sessions were; yet, in spite of this, she referred to them as her "respites from despair."

It saddens me to report that Lucille never made the journey from isolation to intimacy. She desperately wanted to, knew that she ought to, but felt that she could not do so. Her low self-esteem had debilitated her, leaving her in an indescribable state of loneliness. What she failed to understand was that the risks of isolation are far greater than the risks of intimacy. In the pursuit of intimacy there is the possibility for rejection and, thus, for loneliness. In isolation, however, loneliness is not risked, it is guaranteed.

The Church as a Therapeutic Agent

Christians in any local congregation need to understand that there are many lonely people among their number. Their life-situation may not be as desperate as that of Lucille's, but their basis for loneliness, a low self-esteem, is the same as hers. Lonely Christians. Those two words should never be found

together in a Christian community. I say that because I firmly believe that the church should be a therapeutic agent, that it should reach out to the Lucilles in its fellowship and help them to make the journey from isolation to intimacy.

To say that the church has a responsibility to lonely people is not to say that lonely people do not bear their own responsibility for conquering their feelings of alienation and aloneness. Indeed, lonely people do have that obligation, but it is one they cannot easily assume. Such people will need all of the help the church can give in order to conquer their loneliness.

Some mathematically minded Bible scholar has calculated that the expression "one another" appears 58 times in the New Testament. As Christians we are to love one another, sing psalms to one another, admonish one another, and pray for one another. A clear recognition of the "one anotherness" of the Christian community will release the therapeutic potential that Christ has built into His Church.

The word *church* can be used as an escape from individual Christian responsibility in this therapeutic ministry. To be sure, the very meaning of *church* is corporate at its core; therefore, the church has a corporate responsibility to its constituents. That corporate responsibility, however, is realized best as each member seeks to be a therapeutic agent. When you go to church next Sunday, look for Lucille. She will be there (alongside many of her kind) feeling totally unloved and unutterably lonely. You can be sure that she will be plagued with the feeling that a frowning Face is viewing her as she views herself, thus compounding her sense of alienation and loneliness.

*

Out in the highways and byways of life,
 Many are weary and sad.
Carry the sunshine where darkness is rife,
 Making the sorrowing glad.

Give as 'twas given to you in your need;
 Love as the Master loved you.
Be to the helpless a helper indeed;
 Unto your mission be true.†

—Ira B. Wilson

*

He is like a father to us,
 tender and sympathetic
 to those who reverence him.
 —Ps. 103:13, TLB

9 God the Father

The question of the ages has been, "What is God like?" From the dawn of man's consciousness this has been one of his most absorbing questions. Philosophers have pondered it, theologians have debated it, all have wondered about it.

Jesus came to earth to reveal to us what God is like. He said, "He that hath seen me hath seen the Father" (John 14:9). This means that if we want to know what God is like, we have only to look full in the face of Jesus. A little boy, whose theology was better than his grammar, said, "Jesus is the best picture God ever had took." How true that is! Reflected in the life and ministry of Jesus is the very nature of God the Father.

Not only did Jesus show us what God is like, but He also told us what God is like. With few exceptions, when Jesus referred to God He used the term *Father.* He called God *the* Father, *holy* Father, *heavenly* Father, *righteous* Father, *my* Father, and *your* Father. But there is yet another. He said, "When ye pray, say, *'Our* Father . . .'" *Our* Father. That means that we have a common Father with Christ. That relationship places us firmly in the family of God.

The easiest way to know God is to see Him as a Father. A valid description of God is this: God is like the best father you know if you subtract man's weaknesses from him and multiply the remaining good into infinity. God is the very essence of the concept "father." Jesus' great parable—the prodigal son —is the clearest teaching that He gave us regarding the nature of God. It is most unfortunate that the parable of the prodigal son has been so named by Bible publishers. This places the focus on the wrong person. The central figure is not a bad boy; rather, it is a good God. As we examine the parable more closely, we will see that it centers in the nature of God the Father himself. It shows us clearly the Father's love, which releases, looks, runs, forgives, restores, resurrects, and celebrates.

A certain man had two sons: and the younger of them said to his father, Father, give me the portion of goods that falleth to me. And he divided unto them his living. And not many days after the younger son gathered all together, and took his journey into a far country, and there wasted his substance with riotous living. And when he had spent all, there arose a mighty famine in that land; and he began to be in want. And he went and joined himself to a citizen of that country; and he sent him unto his fields to feed swine. And he would fain have filled his belly with the husks that the swine did eat: and no man gave unto him. And when he came to himself, he said, How many hired servants of my father's have bread enough and to spare, and I perish with hunger! I will arise and go to my father, and will say unto him, Father, I have sinned against heaven, and before thee, and am no more worthy to be called thy son: make me as one of thy hired servants. And he arose, and came to his father. But when he was yet a great way off, his father saw him, and had compassion, and ran, and fell on his neck, and kissed him. And the son said unto him, Father, I have sinned against heaven, and in thy sight, and am no more worthy to be called thy son. But the father said to his servants, Bring forth the best robe, and put it on him; and put a ring on his hand, and shoes on his feet: and bring hither the fatted

calf, and kill it; and let us eat, and be merry: for this my
son was dead, and is alive again; he was lost, and is found
(Luke 15:11-24).

The Father's Love That Releases

When the prodigal son chose to leave home for the far
country, the father acceded to his request. The son's choice
was certainly not the father's choice, but he honored his deci-
sion.

God grants man the power of choice. The right to choose
is one of the major differences between man and the rest of
God's creatures. It can be man's crowning glory or his greatest
curse. In the prodigal's case, his choice became his curse be-
cause he chose to go from God rather than stay with God.

God's love is a love that releases. He gives man the right
to go his own way and to live his own life. God grants man the
right to *be* wrong and to *do* wrong. That is why the father
released his son. But though God releases, He still cares. God
releases externally, but He never releases internally. The father
let his son go out of his hand but he did not let him go out of
his heart. He knew that as long as he retained his son by force,
the son was not truly his. He knew that the son could be a son
only as a result of a dual choice—his *and* his son's.

In relationships we have only what is given to us. The
father was well aware of this, and that is the reason why he
released his son. He did so with the hope that his son would
return.

Someone has said that life swings between a risk and an
opportunity. So does love. The father risked the loss of a way-
ward boy for the opportunity of gaining a repentant son.

God's love is the love that releases, but though it releases,
it always cares.

The Father's Love That Looks

Jesus said that the father saw the son "a great way off . . ."

The prodigal had been in the "far country," which, as Ellis Fuller said, is anywhere one is if he is without God. Separation did not hinder anticipation. Distance and time did not keep the father from looking longingly for his son to return.

Seeing the son "a long way off" suggests that periodically throughout each day of separation the father lifted his head, shaded his eyes, and carefully scanned the horizon in the hope that this would be the moment of his son's return. That *must* have been the way it was, else how could the father have instantly spotted his son the moment he came into view?

How different the parable would have been if the father had not been eagerly looking for his son; if, rather, the son had slinked through the back gate unnoticed by the father, later to be greeted with a curt, "Oh, it's you, is it?"

It is the long look of love that tells us what we need to know about the nature of God. It shows us a heart of compassion that only a great God could possess. It demonstrates God's driving desire for fellowship with His children. It tells us that God is more concerned with forgiveness than with judgment.

Love looks long. It looks beyond the many hurts and sins that separate us and enables us, like the father, to see the person and not his past. Love helps us focus on what the future can be, not what the past has been. May we, like God, learn to cultivate the long look of love.

The Father's Love That Runs

It is said that the only record in the Bible when God was in a hurry was when the father *ran* and embraced the prodigal son. In studying Scripture one is impressed with the deliberateness of God. Sacred history is a record of the patience of providence. God acted slowly through the period of the patriarchs. He was not in a hurry during the long period of the Law. He invested several hundred years revealing himself in the period of the prophets. Last of all, the Bible says, He sent His

Son (Matt. 21:37). Thousands of years elapsed during God's dealings with man before His plan of salvation was completed in Christ. Yet, it was this same God who *ran* to receive His son back into His fellowship!

Love is quick to forgive. It has no desire to keep a record of wrongs (1 Cor. 13:5). It does not delight in holding a delinquent in a deadlock of probation. Love does not delay reconciliation; rather, it runs to restore relation.

The image of the father running toward the son is the reverse view many persons have of God. Rather, they see Him standing His ground and scowling as His son slinks home. But that is not Jesus' image of God. He does not tell us of a Father who stands and scowls; He tells us of a Father who runs and embraces. That is the true nature of God—a Father who runs to receive.

The Father's Love That Forgives

William Barclay told of a Sunday School class of youngsters who were hearing the parable of the prodigal son for the first time. Interrupting the story before its conclusion, the teacher asked them what the father should do to the sinful son when he returned. "Bash him," was the reply of one youngster. From the viewpoint of justice, that was a good answer. But from the viewpoint of love, the answer was as wrong as it could possibly be. Justice bashes, but love forgives.

The difference between bashing and forgiving is one of the differences between humanity and divinity. The human reaction to hurt is to return the hurt. Man has a strong sense of justice, of fair play. When he is wronged he instantly thinks of retaliation. Our lawsuit-conscious age is proof positive that man has a keen sense for protecting his own rights. God is not that way. The father did not give the prodigal what he deserved. He deserved justice and judgment; he received mercy and forgiveness. He earned punishment; he was granted grace.

What a desperate plight it would be for us if God treated

man as man treats man! No one could survive. All have sinned, the Bible says (Rom. 3:23). Yet God responds with love, not justice. God has every right to bash, but He forgives instead.

Man is most Godlike when he forgives. No other description of godliness—praying, trusting, believing, or even serving—approaches the quality of forgiving. In a sense these other qualities can be done by sheer human grit. But to forgive we must have divine grace. "To err is human," Alexander Pope said, "but to forgive, divine." Divine forgiveness is best expressed by the father's forgiving love that he granted to his prodigal son.

The Father's Love That Restores

The son had planned to say to his father, "I am no longer worthy to be called thy son, make me as one of thy hired servants." This decision was made as he was standing ankle deep in the muck and mire of a pigpen. But when the father met him, the son was able to say only the first part: "I am no longer worthy to be called thy son." The restoring love of the father restrained him from saying the remainder: "make me as one of thy hired servants." "Not worthy"—that was confession enough. The son did not need to impose his own sentence of servanthood.

The prodigal was hoping to be retained as servant, but he was restored as a son. The father said, "Bring forth the best robe and put it on him." Robes are not for servants. Servants wear rags, not robes. Only a son could wear a robe. And not just *a* robe—the *best* robe. What restoration!

The father had all of the servants he wanted, but he did not have all of the sons he needed. Only one son short, shouldn't that have been close enough? Indeed not. There is an infinite difference between a servant and a son. The father could have managed without another servant, but he could not be content without his son.

Only grace can bring us from where sin has taken us. This is the restoring love of God. He does not give us what we deserve (judgment) or even what we request (servanthood); rather, He gives us what we need (sonship). When his action has caused alienation, man's greatest need is for restoration. Only a loving Heavenly Father can do that. If *that* isn't love, pray tell, what is?

The Father's Love That Resurrects

When the prodigal returned, the father exclaimed, "My son was dead, and is alive again." The son's departure had caused his death as far as the relationship with his father was concerned. The son's "death" was death of the worst kind.

Losing a loved one in a relationship can be worse than losing a loved one by death. In the latter, death happens *to* a loved one; in the former, death happens *in* a loved one. When death happens *to* a loved one, there is one who dies and one who is left to hurt. When death happens *in* a relationship, there are two who survive and two who are left to hurt. Thus, a division caused by difference can be worse than a division caused by death. When one has been deeply hurt by another, as in the case of separation or divorce, the dramatic remark is often made, "I'd rather see him in his coffin than to have this happen." There is more truth than drama in that statement.

A division by death is gradually healed through a process that psychiatrists call "grief work." In a division of difference, grief work cannot easily take place because there are two survivors. But the hurt is there, and it can be worse than the pain of bereavement.

When the prodigal left home, the relationship with his father was shattered. Relationally, the son was dead. How keenly the father felt that loss! He grieved for his son, but it was grief work that could never be finished. That is why the father kept looking for his son and at long last saw him "a great way off." When his long look of love was rewarded, he

ran and embraced his son. As far as the father was concerned, his son was not returning from a trip; he was returning from death. He said, "My son was dead and is alive again." Only love can resurrect a relationship that is dead.

The Father's Love That Celebrates

After restoring the prodigal to sonship, the father ordered a celebration. His command was to kill a fattened calf so that there could be a banquet. The father said, "Let us eat, and be merry."

The celebration was for the father's benefit, not the son's. True, the son needed food. Had he not earlier been so hungry that pigs' food looked good to him? But he could have had his hunger satisfied without having a celebration. It was the father who *needed* the celebration. It was an opportunity to let his joy find full release through festivity.

Important events call for celebration. Weddings, graduations, accomplishments, and victories all give occasion for celebration. When something *important* happens it is just not enough to say, "That's nice," and then go on with the routines of life. Rather, the impulse is to mark the event with festivities.

It is difficult to picture God in a festive mood if we are living with a distorted image of His nature and character. But if we see God as Jesus tells us we are to see Him—as Father—it is easy to see Him celebrating an important event in the life of His children. After all, He *is* a Father.

The Bible tells us that there is joy in the presence of God's angels over one sinner who repents (Luke 15:10). The contagion of celebration that begins with the Father himself spreads to His angelic hosts! A Father who celebrates—what a glorious picture of God.

*

I once was an outcast stranger on earth,
A sinner by choice, an alien by birth!
But I've been adopted; my name's written down.
I'm heir to a mansion, a robe, and a crown!

—Harriet E. Buell

*

But we all,
 with unveiled face
 beholding
 as in a mirror
 the glory of the Lord,
are being transformed
into the same image
from glory to glory.

—2 Cor. 3:18, NASB

10 Changing the Image of God

Many persons need to have a radical change in their image of God. Indeed, it must be changed before they can fully experience the love of God the Father. He cannot be the God He wants to be unless, and until, the image of Him is changed. The good news is that it can be changed. It is not simply and easily done, but it can be done. That should be heartening to many who are attempting to come to a clearer, and better, understanding of the nature and character of God.

Changing one's image of God is essentially an unlearning process. As was stated earlier, people are not born with a distorted view of God, it is a learned process, acquired primarily through the influence of significant people in their lives. What can be learned can be unlearned. To say it a better way, faulty learnings can be replaced with accurate learnings, and faulty perceptions can be replaced with valid ones.

The primary aspect of changing one's image of God is the process of subjecting one's feelings about God to the testimony of Scripture. It is a biblical-cognitive process that forces the emotions to be submitted to the authority of Scripture. This will evidence itself in a number of ways. We will now examine some of them.

Understanding That God's Wrath Is Toward Sin

That God is a God of wrath is clearly supported by Scripture. What the Christian needs to know, however, is that His wrath is reserved for the willfully disobedient, not for His children who are seeking to love Him and to serve Him. John wrote,

> If anyone acknowledges that Jesus is the Son of God, God lives in him and he in God. And so we know and rely on the love God has for us. God is love. Whoever lives in love lives in God, and God in him. Love is made complete among us so that we will have confidence on the day of judgment, because in this world we are like him. There is no fear in love. But perfect love drives out fear, because fear has to do with punishment. The man who fears is not made perfect in love.
>
> We love because he first loved us *(1 John 4:15-19, NIV)*.

John makes it clear that we can rely on God's love because He *is* love. That love assures us that we will have confidence on the day of judgment. John also assures us that there is no fear in love. The person who is in a loving relationship with God cannot become a victim of the wrath of

God. The mind must fully grasp the deep significance of this biblical truth so that it can force the emotions to accept it.

For some, this will not be an easy procedure because of the power of the emotions. As was stated earlier, one must distinguish between real feelings and valid feelings. The Christian who is terrified of God has real feelings; that is, those feelings are all-pervasive and persistent. But regardless of how painfully real they are, they are not valid. They are not valid because God, in His Word, has declared otherwise.

Martin Luther struggled throughout his life with the issues of self-acceptance and of God's acceptance. To help himself when he was in the throes of deep doubts, he scrawled in large print on his desk these words to remind himself: "I have been accepted by God." He used a biblical-cognitive approach to overcome the power of his negative emotions. Again, this is not an easy task, but it promises release to those who are struggling with self-acceptance and acceptance by God.

Understanding That God's Judgment Is Designed to Produce Repentance

The Bible, especially the Old Testament, records numerous accounts of the judgments of God upon His wayward people. These judgments of God were not meted out to satisfy the demands of a sadistic God. They were designed, rather, to make people turn from their wicked ways to Him.

The central message of the Book of Jonah illustrates this clearly. The sins of Nineveh were many and hideous. God instructed Jonah with these words: "Arise, go to Nineveh, that great city, and cry against it; for their wickedness is come up before me" (Jonah 1:2). Jonah refused because he felt that God was the God of the Hebrews only, that heathen had no rights to his God.

Here we see another example of how one's image of God affects one's behavior toward God. "But Jonah rose up to flee unto Tarshish from the presence of the Lord" (Jonah 1:3).

Jonah viewed God as a local deity. This meant that by removing himself from where God called him, he would be removing himself from God. Absurd? Yes, but do we not also do injustice to God by perceiving Him inaccurately? Oh, the power of our perceptions! They not only harm us but they can also alter the designs of deity. Some of the saddest words of Scripture are these: "They . . . limited the Holy One of Israel" (Ps. 78:41).

After Jonah's deliverance from the great fish, the Bible records these words: "And the word of the Lord came unto Jonah the second time, saying, arise, go unto Nineveh" (Jonah 3:1). God is the God of a second (and third, and fourth) opportunity. His judgment upon Jonah, which led to his rescue, was followed by granting him an opportunity for repentance and a second opportunity for service.

Jonah seized that opportunity. His preaching to Nineveh precipitated a great revival and God withheld His judgment. Jonah reacted as follows: "But it displeased Jonah exceedingly, and he was very angry" (Jonah 4:1). Jonah said, "I *knew* that thou art a gracious God, and merciful, slow to anger, and of great kindness" (Jonah 4:2, emphasis added). Jonah *knew* that but *felt* otherwise, and his feeling became the basis for his behavior.

Jonah openly expressed his anger to God, and he survived! He was not the first, nor was he to be the last, to be angry with God. Even in Jonah's anger God was patient with him, using it redemptively for Jonah's good. God saved a city of 120,000 people, demonstrating that He is more concerned with repentance than with judgment.

Understanding That Feelings About Self Are Not Equated with God's Assessment of Self

Each of us is in a continuous dialogue with the self. Sometimes we actually talk out loud to ourselves, especially when we think no one is listening, but more often we speak to

ourselves through our thoughts about ourselves. Self-thoughts are self-language and, in that manner, we are to some degree or another addressing ourselves through the day.

A person with a low self-esteem can easily fall into a pattern of self-language that is negative, that centers in putting oneself down. Self-depreciation produces depression and depression produces more self-depreciation. One who has engaged in this process for a prolonged period loses a sense of worth and a sense of self-identity that produces feelings of alienation from oneself. When that happens it almost invariably follows that he will assume that others will feel toward him as he feels toward himself. The next step in this process is to assume that God also feels that way toward him. This condition may be diagrammed with three interlocking circles as follows:

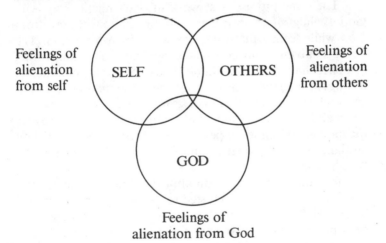

Feelings of alienation from self

Feelings of alienation from others

Feelings of
alienation from God

The key word in this diagram is *feelings.* We are not dealing with objective reality, remember, only feelings. But because of the power of emotions, one can easily assume that feelings and reality are the same.

So closely related are these three elements (feelings of alienation from self, from others, and from God) that focusing on any one of them will almost automatically affect the other two.

Persons with low self-esteem have a fear of in-depth relationships because they have a fear of being rejected by others. Given the premise that one is of no value, does it not seem correct to assume that others would concur with that self-assessment? The tendency, then, is to withdraw from others, while feeling that others have withdrawn from him. This confirms that others see him of no value, which also confirms that one is of no value. An unsuitable alternative to withdrawal is to put on a mask in order to be accepted by others, not realizing that if one's mask is accepted, the person behind it has still not been accepted.

The same process is at work in one's relationship with God. Feelings of unworthiness can make one withdraw from God while feeling that God has withdrawn from him. The feelings of being unloved by God, again, become confirming evidence that one is of no value. Thus, the cycle is completed: feelings of alienation from self, feelings of alienation from others, and feelings of alienation from God. This is repeated again and again and again. With each repetition of the cycle, the individual feels less a person and of less value. It is like an airplane in a tailspin; it is only a matter of time until the "crash" comes.

For some, the crash is an almost-debilitating depression that leaves the person exhausted to the point of being immobilized. For others, the crash is an awareness that there must be some intervention to relieve the pain of isolation. Such persons are likely candidates for alcohol or drug abuse, both of which are escape methods. Escape from self becomes the underlying motive, though other factors are likely to be named, such as escape from boredom, escape from physical pain, escape from disappointment, and escape from "society."

The ultimate escape is suicide. It might be shocking to many to know how many Christians have thought seriously of taking their own lives. I am not talking about fleeting thoughts of suicide; rather, I am referring to those who have often wished to die and have already decided how to do it but cannot bring themselves to perform the act.

How does God figure in all of this? Is He as uncaring as some feel He is? Indeed, does He reject those who are attempting to love Him and to serve Him? The answer, of course, is no. God is not like that even though some feel that that is the way He is. What assurance do we have that He is not that way? The Bible repeatedly and clearly says that He is the reverse of that. Jesus said, "Behold the fowls of the air: for they sow not, neither do they reap, nor gather into barns; yet your heavenly Father feedeth them. Are ye not much better than they?" (Matt. 6:26).

In the Old Testament a familiar image of God is that of a father who tenderly cares for his child, seeking to guide and guard him, and desiring to be at one with him.

Understanding That Jesus Is God the Father Incarnate

This means that one's image of God the Father must be tested against the biblical record about the life and nature of Jesus. Any image of God the Father that is at odds with the character of Jesus must be discarded. A person wrote to me and said, "I feel closer to Jesus as Lord than to God as Father." That, of course, is theological nonsense, for the Father and the Son are one. But there is that troublesome word again—*feel*. The person who wrote that was well aware of the incongruity of his statement, but he permitted his feeling to negate his knowing, thus producing a feeling of distance from God the Father.

We need to learn that Jesus is God's self-disclosure. From the beginning of God's relationship with man He sought to disclose himself. Indeed, the creation of man was itself a form

of God's self-disclosure. From the time of Adam, God has sought to make himself known to man. The one, irreducible message of God to man throughout the ages is this message: "I love you." He said it in the period of the patriarchs, He said it in the period of the Law, and He said it in the period of the prophets. But He said it most profoundly in Christ. The biblical record is,

> In the past God spoke to our forefathers through the prophets at many times and in various ways, but in these last days he has spoken to us by his Son, whom he appointed heir of all things, and through whom he made the universe. The Son is the radiance of God's glory and the exact representation of his being *(Heb. 1:1-3a, NIV)*.

The message is clear: God has spoken in His Son, revealing in clear and unmistakable terms how He feels about us. His eternal "I love you" was said fully, and finally, in Christ. God could not have said it any better than He did. But He keeps saying it in the life and the nature of His Son. "God was in Christ" is Paul's terse yet complete and profound way of stating it (2 Cor. 5:19). In Col. 2:9 (NIV), Paul said, "For in Christ all the fullness of the Deity lives in bodily form."

Christ is "the exact representation" (Heb. 1:3, NIV) of the Father. What we see in Christ—His compassion, His concern, His care—is what God is. Jesus said, "I and the Father are one" (John 10:30, NIV). That means that the character of the Father is fully disclosed in the nature of His Son.

The manner of God's self-disclosure in Christ is mind-boggling. God disclosed himself in the form of a baby. The Almighty God did not disclose himself in a violent display of His power. Rather, He disclosed himself in the form of a helpless, lovable baby. Of all of the options for self-disclosure that were open to Him, He chose this one. It was a purposeful act, done to make himself known to man in the least frightening way. A baby has magnetic appeal. Our hearts reach out in love

to a baby, just as the Father reached out to us in love in the sending of His Son.

Since Jesus is "the exact representation" of God, or as Paul said, "He is the image of the invisible God" (Col. 1:15, NIV), we no longer need to wonder what God is like. Nor do we need to wonder how He feels about us. The grand truth is this:

> But when the time had fully come, God sent his Son, born of a woman, born under law, to redeem those under law, that we might receive the full rights of sons. Because you are sons, God sent the Spirit of his Son into our hearts, the Spirit who calls out "Abba, Father." So you are no longer a slave, but a son; and since you are a son, God has made you also an heir *(Gal. 4:4-7, NIV)*.

On one occasion Philip asked Jesus to show the Father to him and to the other disciples. Jesus said, "Anyone who has seen me has seen the Father" (John 14:9, NIV). The implications of that statement are overwhelming: A look at Jesus is a look at the Father. Look at Christ,

—as a baby in the manger
—as a boy in the Temple
—as a friend at Lazarus' tomb
—as a teacher in the synagogue
—as a healer on the wayside
—as a preacher on the mount
—as a Savior on the Cross

When the Swiss theologian, Karl Barth, came to the United States to lecture, a young theological student asked him to summarize his Christian faith. The great scholar, whose theological writings are both numerous and profound, pondered the matter and then replied, "If I had to sum up Christianity, I think it would be what my mother taught me— 'Jesus loves me, this I know; For the Bible tells me so.'"[1] Christian faith cannot be stated more simply, nor more profoundly, than that.

E. W. Kenyon said, "When I saw what God had done for me in Christ, my whole being was thrilled. . . . I said 'Thank you, Father' and I began to enjoy my rights in Christ."[2]

When you look at God the Father, what do you see? I pray that you will see the face of the Lord Jesus, the exact representation of His Father, who is also *our* Father.

*

Since from His bounty I receive
Such proofs of love divine,
Had I a thousand hearts to give,
Lord, they should all be Thine;
Lord, they should all be Thine.

—Samuel Stennett

*

Reference Notes

Chapter 1

1. William L. Stidger, *Sermon Stories of Hope and Faith* (New York: Abingdon-Cokesbury Press, 1948), 117.

2. J. B. Phillips, *Your God Is Too Small* (New York: Macmillan Co., 1961).

3. A. Durwood Foster, *The God Who Loves* (New York: Bruce Publishing Co., 1971), 37.

4. Paul T. Culbertson (quoted in an address given at Pasadena College).

Chapter 2

1. A. Donald Bell, *The Family in Dialogue* (Grand Rapids: Zondervan, 1968), 89.

2. John A. Larsen, "Which Theology Will Win?" *Colloquy* (A quarterly paper distributed by the Midwest Christian Counseling Center, Kansas City, March 1981).

3. Roy L. Smith, *Making a Go of Life* (New York: Abingdon-Cokesbury Press, 1958), 185.

4. Paul Sangster, *Pity My Simplicity* (London: Epworth Press, 1963), 43.

5. H. A. Ironside, *The Continual Burnt Offering* (New York: Loizeaux Brothers, 1956), not paginated.

6. Roy L. Smith, *Making a Go of Life,* 56.

7. H. A. Ironside, *Continual Burnt Offering,* not paginated.

Chapter 4

1. A. W. Tozer, *The Knowledge of the Holy* (New York: Harper & Row, 1961), 10.

Chapter 6

1. John Baille, *A Diary of Private Prayer* (New York: Charles Scribners Sons, 1949), 75.

Chapter 7

1. Herman W. Gockel, "Our Infinite God," *This Day* (quoted in *Quote,* October 13, 1963, vol. 46, No. 16, p. 10).

2. Robert V. Ozment, *There's Always Hope* (quoted in *Quote,* April 4, 1965, vol. 49, No. 14, p. 3).

3. Bruce Larson, *Setting Men Free* (Grand Rapids: Zondervan Publishing Co., 1967), 96.

Chapter 8

1. Viktor Frankl, *Man's Search for Meaning* (New York: Washington Square Press, Inc., 1963), 167.

2. Albert Camus, *The Myth of Sisyphus* (New York: Alfred A. Knopf, Inc., 1955), 15.

3. Wayne Oates, *Christ and Selfhood* (New York: Association Press, 1961), 248.

4. Ibid., 241-42.

5. Samuel M. Shoemaker, *By the Power of God* (New York: Harper and Brothers, 1954), 67.

6. John Powell, *Why Am I Afraid to Tell You Who I Am?* (Chicago: Argus Communications Co., 1969), 69.

7. Sidney Jourard, *The Transparent Self* (Princeton, N.J.: D. VanNostrand Co., Inc., 1964), 21.

8. Ibid., 25.

Chapter 10

1. Morris Chalfant, "Feed the Lambs, Not the Giraffes," *Ministry,* November 1982, 21.

2. E. W. Kenyon, *The Two Kinds of Faith* (Lynood, Wash.: Kenyon's Gospel Publishing Society, 1969).